EDWARD HILL

THE LANGUAGE OF DRAWING

A SPECTRUM BOOK

PRENTICE-HALL, INC., ENGLEWOOD CLIFFS, NEW JERSEY

for Rico Lebrun

EDWARD HILL,
the author of this book,
is Assistant Professor of Art at Smith College.
In 1964 he received a National Institute of Arts and Letters Award
and has held a McDowell Fellowship.
His work is represented in numerous private and public collections
and is exhibited both in this country and in Europe.

Current printing (last number):

10 9 8 7 6 5 4

Preface

Consuming projects from small ambitions grow. *The Language of Drawing* began in 1961 with no grander intention than to write a short article "defining" *drawing*. With the encouragement of Dr. Gulnar Bosch of Florida State University, the idea was expanded to a more complete exploration of the subject. The metamorphosis of my thought over five years brought this exploration and examination to its present form. Essentially the book remains an attempt to define *drawing*. The word "attempt" is important here because one does not exact a definition from such a boundless and protean term; hopefully, however, the attempt reveals to us something of the vast artistic organism which we call *drawing*.

The line of attack I have taken is neither historical nor technical (how to draw) but, rather, conceptual; moving in a more or less direct line through my own experience as a draftsman, through my assimilation of the various ideas to which I have been exposed, through looking at many, many drawings, and finally through my experience of instructing. The result is a measure (in both senses of the word) of drawing which I desire to be at once personal and catholic.

A word about the drawings reproduced. The list of illustrations should not be construed as a synoptic representation of great draftsmanship. Where

are Degas, Rubens, Dürer, Raphael, Van Gogh, and Matisse? Or other draftsmen for whom one may have a high regard? They are obviously missing. But their absence is owing to practical concerns only. The book is an exploration and exposition of ideas, not an anthology; therefore the drawings chosen were those which would be most helpful to me in this task.

My acknowledgments of debt and gratitude are certainly no less extensive than most writers': to Robert C. Townsend of Amherst College and David Brooke of The Art Gallery of Toronto for their willingness to wrestle with the manuscript in its early stages, and their pertinent suggestions; to George Cohen, who brought a number of sources to my attention; to Leonard Baskin, for the use of his collection of master drawings and copy-books, and for many profitable conversations; to John Roy of the University of Massachusetts, who long ago put the thought of writing this book in my mind; to Hui-Ming Wang for his knowledge of Chinese calligraphy; to Gulnar Bosch, already mentioned; to my wife for many reasons, not the least of which is her patience; and to Mary Sullivan, for her typing, editing, and counsel.

For their generous cooperation, I am grateful to those private collectors and museums who permitted me the use of works in their collections.

Finally, and not entirely out of whimsy, I want to acknowledge those bashful spirits, the draftsman's intrepid Muse and that of the writer, Miss Poesy.

Contents

Illustrations

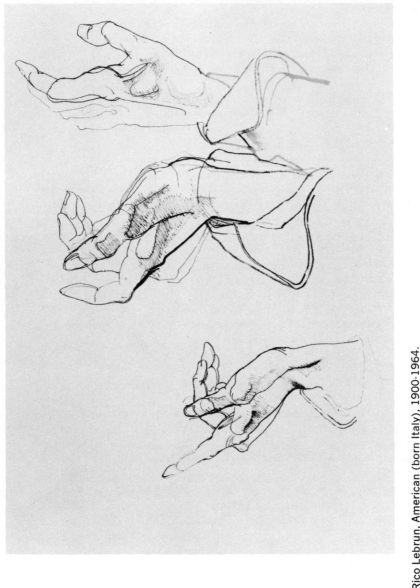

Rico Lebrun, American (born Italy), 1900-1964.
Hand (1964), pen and ink.
Courtesy of David Lebrun.

ONE

A Definition

Many common words whose meanings we take largely for granted prove, on close examination, to represent a much broader, more effluent concept than we had been aware of. *Drawing* is such a word. Few of us recognize the full sense of this term; instead we tend to apply thin and limited meaning, using *drawing* to represent the particular idea with which we happen to be familiar—in most instances a rather narrow, parochial idea.

What, then, is "drawing"?

Drawing turns the creative mind to expose its workings. Drawing discloses the heart of visual thought, coalesces spirit and perception, conjures imagination; drawing is an act of meditation, an exorcism of disorder, a courting of artistic ideas; above all it is the lean instrument of visual formulation and the vortex of artistic sensibility.

Yes, we can appreciate the truth of such rhetorical definition, but it provides the spirit without the bones. To obtain a sense of the complete organism of drawing, it is necessary first to discover the seed. The seed lies in the verb *to draw*. To draw requires an action, a performance, and this—the *act* of drawing—is the genesis of our subject. No more inclusive or elemental observation can be made than that drawing is a physical act; and yet, despite the obviousness of this point, its signifi-

cance can hardly be overstated. Every drawing reproduced in this book reflects the excitement of the moving hand, whether acting slowly and deliberately and rephrasing, or moving so swiftly, so powerfully that it quickens our breath and propels us, caught in the ease and wonder of the performance, along its course. The scribblings of any three-year-old child clearly indicate how thoroughly immersed he is in the sensation of moving his hand and crayon aimlessly over a surface, depositing a line in his path. There must be some quantity of magic in this alone.

Speculating about the origin and evolution of drawing, we may suppose paleolithic man innately to have sensed the power of the drawn line as he idly traced with finger or stick in soft earth. Slowly, over a great span of time, the phenomenon of line must have become associated with a larger share of man's experience—the trajectory of moving life. The traced line could then act purposefully and potently in the ritual of his daily existence. Once the broader power and significance concealed within the kinetic line has been released, the concept of drawing obtains a wholly grander dimension of profundity, as is the case with the cave drawings of Altamira and Lascaux. Certainly these vital meanings are our final concern. For the present, however, we shall consider gesture, i.e., the act of making a line or mark, for this is the fundamental unit of drawing.

The making of a single stroke represents a conjuncture of three factors: materials, muscular action, and pictorial (artistic) intention. Perhaps no more explicit rendering of these can be found—bound in consummate union—than in a masterwork of Chinese calligraphy. In many ways the brush-writing of the Orientals possesses more of the essential spirit of drawing than a great number of works Westerners categorize and prize as exemplary of this art. The oriental writing-master conceives of his art as a choreography of brush and hand; accordingly, we may apply critical standards to it similar to those of the dance. It is a disciplined performance acted out with surety, grace, vitality, and—above all—total participation.

Huai Su's "grass style" calligraphy (Figure 1), a highly cursive style

Figure 1
Huai Su, Chinese, T'ang Dynasty.
Panel of calligraphy, brush and ink on silk, $9\frac{3}{4} \times 4\frac{5}{8}''$.
Palace Collection, Taiwan.

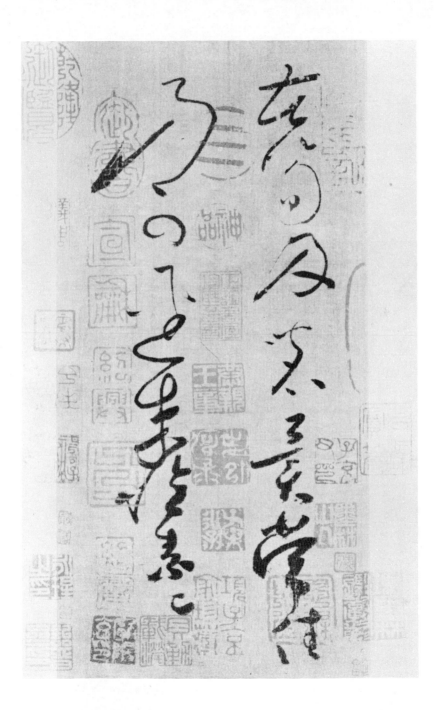

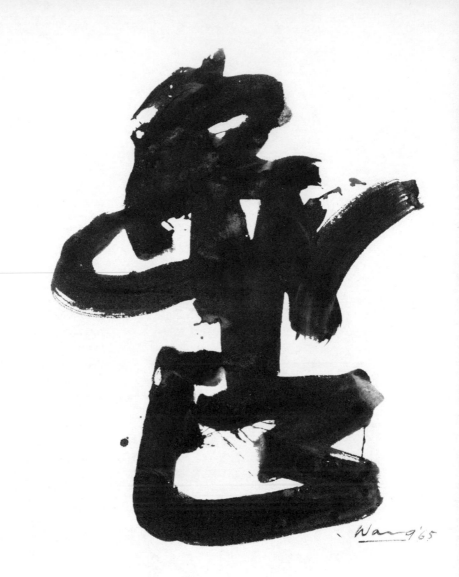

Figure 2
Wang Hui-Ming, American (born China), 1922 —.
Untitled (1965), brush and ink, 24 × 18″.
Courtesy of the artist.

of writing, vividly characterizes the oriental conception of gesture as a quickening force. The fluent, fragile characters are at once abstract and organic: abstract because they "picture" nothing other than the inherent qualities of the lively, fluid line; yet they possess more than a semblance of nature, for their organic structure derives directly from the oriental awe of natural phenomena. Here we are given an equation: the spirit of the master's brushwork equals the harmonious spirit of nature. One feels in these strokes a sense of living things (columbine shifting lightly in barely perceptible breeze), as was certainly Huai Su's directing principle. This feel for natural fact underlies the cultivation of skill and sensibility.

The weight of emphasis in the Chinese aesthetic rests upon the quality of brushwork. Good brushwork must be firm, virile, bold, and fluent, but also delicate, discriminative, and exquisitely disciplined; never belabored, languid, or wooden. In no way should the brush be inhibited, neither by a feeble nor by a stubborn mind, for freedom is the absolute aim. Freedom of gesture (movement) exhilarates. Huai Su creates with endless variation as his line moves down the panel without hesitation, without repetition of gesture or placement, continually surprising in its asymmetry, maintaining a vital momentum throughout. He displays within this small space a diverse vocabulary of movement, the full capability of the oriental brush itself. The rest—the visual poetry—is ineffable.

To empty one's mind of all thought and refill the void with a spirit greater than oneself is to extend the mind into a realm not accessible by conventional processes of reason. Wang Hui-Ming, a contemporary Chinese-American painter, pursues such a course in the drawing reproduced here (Figure 2). The stark, black figure is a spontaneous symbol which represents an abrupt release from the reason-bound mind into a state of emancipation, and a participation in the larger dimension, the Unconscious, as understood in Chinese thought. Emancipation of mind and freedom of gesture are in effect identical.

Wang does not reinterpret the writing tradition so much as he creates a contemporary expression based on this tradition. (The figure is not an actual calligraphic character.) With deliberate severity, he reduces the conception of drawing to essentials and everything becomes focused upon the immediate act. In such a concentrated work it is easier to assay the anatomy of gesture; let us then examine it in terms of the three factors already mentioned: materials, bodily action, and intention.

Brush, ink, paper, and inkstone. These are the oriental artist's "treasures."

"The materials of Chinese painting . . . are the same as the simple equipment on the table in a scholar's study. Always held in deep respect, they have long been called wên fang ssŭ pao *(four treasures of the abodes of culture). Each is dependent on the others, and all are highly prized. Each has a long history of development amounting to a pedigree. Each is also endowed with symbolic significance that has enveloped it with layers of meaning."* *

Too—each has its characteristic properties and behavior which the artist must understand thoroughly; and he selects his materials in accordance with his needs. The brush used by Wang is unusually large (three-and-one-half inches long and one inch in diameter), corresponding to his heavy line. Composed of goat hair, the bristles are sturdy enough for the size and capable of retaining a considerable quantity of ink. A cylinder of bamboo holds the bristles and in turn this is held by the artist vertically, close to the top, the hand and arm completely free of the drawing surface; in fact, the character *pi* (brush) depicts the instrument used in this manner.** The oriental brush is a unique instrument. Its particular design, a large belly and finely shaped point, allows for the most responsive and varied play of line of any drawing tool whatsoever.

A carbon inkstick rubbed on slate (inkstone) and mixed with water to a consistency somewhat thicker than commercial India ink produces the velvety black ink of Wang's drawing, an ink almost identical with lampblack watercolor. Since the ink that he mixes is not of even consistency, the pigment being unevenly dispersed in the water, on drying there are irregularities of tone and small areas where pigment has flaked off. The speed of the brushstroke, which creates air bubbles, combined with the texture of the paper, also produces variations in the black line. Although these add a quality of "patina" to the figure, they are not planned or controlled; rather, they are a natural result of the character of the materials. That the ink is neither too watery nor too pasty, that it will flow easily without flooding or running concerns the artist more than any other characteristic.

The only material which does not fit into the traditional pattern is

* Mai-Mai Sze, *The Tao of Painting.* New York, 2nd ed.: 1963, p. 56.
**Mai-Mai Sze, Appendix VII.

the European handmade, wove paper. Less absorbent and fibrous than most oriental papers, its surface permits more rapid movements, at the same time drawing less of the ink down into the fibers, which gives the image greater density. The hardness or softness, roughness or smoothness of papers greatly affects not only the appearance of the marks made upon them, but also the feeling of the drawing tool as it moves over their surfaces. Both these factors are taken into consideration when the draftsman chooses his paper.

Simply described, these are the interdependent material means. Their specific natures can only be known from working directly with these and other types of materials. Together ink and paper become the substance of a visual expression as formed by a complex, sustained performance. Everything in this drawing focuses upon the purity, freedom, and fullness of the act of brush and hand executing in one continuous effort a unique pattern of movements. Wang pursues those qualities traditionally expected of good brushwork with an emphasis on the virile brushstroke. These qualities of gesture are so absolutely interlocked with the pictorial intention that to separate them in discussion would be misleading. The physical balance and readiness of the entire body equate the accord of mind; in fact, one requires the other, and the gesture mirrors this symmetry of mind and body. Conditions must be such that brush, arm, the whole organism are completely free of any hindrance, and mind the same—nothing, above all preconceived actions or thought, may be permitted to bind the freedom of gesture.

The artistic intention of a drawing cannot be reduced to "self-expression" or "representation" or "investigation," for this obscures the complexity of levels at which most draftsmen operate. For instance, a self-portrait crayon drawing by Lovis Corinth (see Figure 8) reflects at least three levels of intention: an intense probing of one's own image; a testing of a particular interplay of shapes, lines, and tones; and the ritual of participation in the wondrous act of drawing itself. Artistic intention in this case is the sum of all these. Wang's drawing narrows its intent toward a more singular goal: neither objective reality nor formal design provides directives; Wang liberates himself of conscious intention or preconception in order to execute an entirely spontaneous choreography guided more by the feelings, by the muscular response of a dancer than by the educated eye. He draws too rapidly for thought or eye to follow. The meditation that precedes the drawing prepares the mind and body to rise above their reason-bound limitations to a plane described as the Unconscious or the *Tao*. No plan as to direction or du-

ration of movement provokes the drawing; his only accepted limitations are the size of the paper and the quantity of ink the brush contains. To stop and refill the brush, he feels, would jeopardize the unity of performance. Thus all weight is placed upon gesture as a free act, and this is his intention.

How important it is to see drawing as a dynamic affair! The marks retained on a drawing surface are symbolic of the act that produced them. When we behold a cursive pen stroke in a Rembrandt we but barely realize the full sense of what lies within the stroke. That single line is a multiplicity: it characterizes the responsive penpoint and the rich tone of bistre ink; it holds the sensation of pen and hand gliding swiftly and firmly but with delicacy over the tender surface, leaving a fine quantity of ink in their trail; it defines the model's thigh, a division of light, and a horizontal movement. The last is the pictorial intention of that line. Once we begin to consider the intention, the purpose, of a single gesture or an entire drawing we move into the larger whole of the subject.

<div align="center">•••</div>

A provisional definition: "Drawing" is the act of making a mark, line, or incision on a surface; and in the larger sense, a participation in the Language of Drawing.

What is this notion, the Language of Drawing? Language functions as a means of collecting, ordering, relating, and retaining experience. We house our memory-thoughts in words and faint images; and the maze of sensations and perceptions that enter in upon our mind are given a form through language, the first instrument of order. Language is both incentive and means to pursue an understanding of experience; in the same way drawing is a symbolic form functioning toward the same end. Drawing diagrams experience. It is a transposition and a solidification of the mind's perceptions. From this we see drawing not simply as gesture, but as mediator, as a visual thought process which enables the artist to transform into an ordered consequence what he perceives in common (or visionary) experience. For the artist, drawing is actually a form of experiencing, a way of measuring the proportions of existence at a particular moment. Because of the directness of the drawn line and the simplicity of the material means, it is the most expeditious form in the visual arts. Drawing, then, is seeing. And this provides the *raison d'être* of drawing.

Pisanello (Antonio Pisano, c. 1395-1455) has become the symbol of

modern drawing for the reason that he was the first great draftsman to conceive of drawing in the manner just described. Scattered among his paintings and medals are a body of drawings—lyric, gentle, and more startlingly penetrating than any graphic work up to or during his time. Pisanello was in the current of so-called International Gothic and sensitive to its altering ideas and shifting focus. But more important to us, he was an inquisitive artist of inordinate perception and insight. The extraordinary level of his vision projected him further into the substance of his models than any draftsman had been before: his depth of perception becomes a multiplier in the equation drawing = seeing.

Pisanello took whatever objects he found in nature as his models, animals most especially. His inquiry, however, did not extend beyond the bounded form of the object-entity, as in his *Rabbit* (Figure 3); at least if he was aware of the relation between object and environment —the forces that act upon an object—neither he nor his contemporaries concerned themselves with these forces in their art. That task was reserved for Leonardo. The silhouette of the rabbit is, then, the boundary of Pisanello's thought. And within that area a pattern of short penstrokes feels out the contours of the animal's form. With these strokes Pisanello discovers something about the living object before him, something beyond the pattern of fur, shape of the ears, nose, and so forth—something which has to do with the totality of this anxious creature who stares nervously at his observer.

Perception is a complex affair. Without considering the fact that artistic vision is of a higher order than common vision, we must realize that drawing can and does heighten visual sensitivity. The requirements of a drawing, that is, the putting together of a comprehensible pattern of lines and so on, prod the draftsman to sharpen his observation beyond the ordinary level. We too, were we to draw the rabbit, would discover that drawing had led us to an understanding of the animal beyond what we previously possessed—even if not to the plane of Pisanello's poetry. In its own way drawing is a means to knowledge.

The marvel of Pisanello's graphic images is that he drew each object with an intensity as though it had never been seen before. For Leonardo, as Pisanello, drawing was ". . . a direct organ for understanding reality." * By the last decades of the fifteenth century Leonardo had honed drawing to an instrument of incredible sharpness, capable of the most precise incisions into reality. No draftsman has conducted examinations of the visible world commensurate with the level and

* Charles de Tolnay, *Master Drawing.* Toronto, 1943, p. 44.

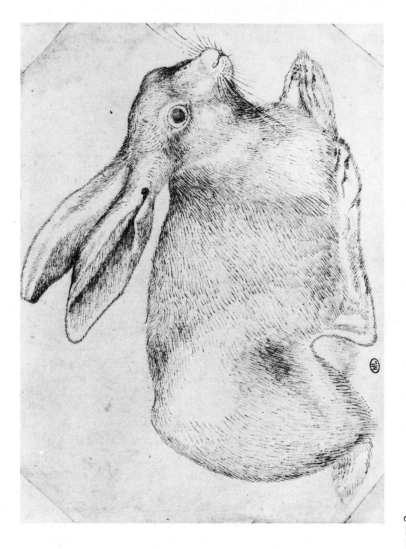

Figure 3
Antonio Pisano (Pisanello), Italian, c.1395-1455.
Rabbit, pen and ink, $5\frac{7}{8} \times 7\frac{7}{8}''$.
Collection of the Louvre, Paris.

scope of Leonardo, who then applied these studies to his inventions and artistic phantasies.

Concepts which have but a vague presence in the mind can be shaped and examined through drawing; which is to say that this medium of exploration can apply not only to objective reality, but may also be turned inward to reveal the forms of imagination. With Leonardo the two interconnect. From his relentless studies he abstracted ideas about proportion, anatomical structure, comparative anatomy, the nature of motion and growth, and so forth, continually driving toward universal principles. A mind such as Leonardo's is led naturally from observation to hypothesis, from things seen to things envisioned. The cataclysm which he rendered so rhythmically (Figure 4) illustrates the extension of drawing into a second realm, the visual imagination. Leonardo's seemingly apocalyptic drawing discloses an imagination grounded in an empirical mind, a pragmatic imagination which attempted to see in natural forces, whether generative or destructive, a governing order. To contemporary eyes, accustomed to photographic records of more exacting instruments, this plate seems little more than an artistic extravagance; but if we can sense the profound necessity of Leonardo's vision, then we may see how his drawings became a kind of theoretic laboratory where perceptual experience and conceptual abstraction could form an image of possibilities.

As we have said, the idea of drawing as an implement of seeing is the *Why* of drawing. Seeing means much more than healthy, open eyes— it is an active condition. Sedulous vision seeks meaning in the seeming chaos of our perceptions, and drawing as an act of seeing gives edge to the manifold levels of experience. Obviously the sense here of *seeing* is intentionally broad and at times metaphorical.

<div style="text-align:center">⁂ ⁂ ⁂</div>

If we enclose the relation between the process of making and the act of seeing, a new unity appears: the union of seeing and making is *form*.

We ordinarily think of form as concrete and measurable, a quality of objects recognized as their three-dimensional shape. In the arts a definition is not so easily rendered; artists and writers on art speak of plastic form, dynamic form, spacial or negative form, linear form, chromatic form, organic and geometric form, classical and baroque form, and so forth. These are each definable. Yet we must give the term an essential base.

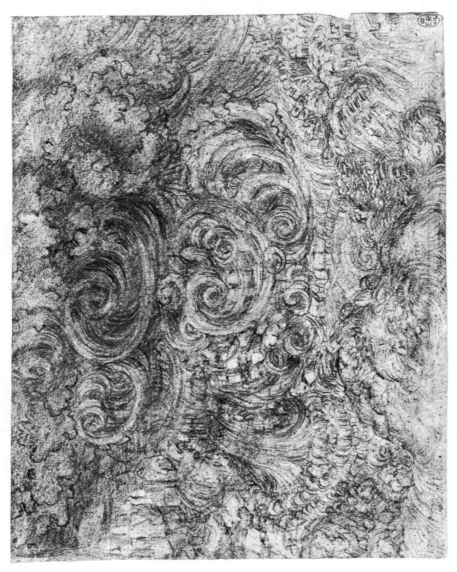

Figure 4

In *Christ on the Cross* by Michelangelo (Figure 5) we are aware first of the individual forms of the composition, the protagonist Christ, the mourning Mary and John at the base of the cross, and the cross itself; second, we recognize the *total form* of the drawing as a whole. This is the fundamental distinction—between the form of the whole and those individual forms that compose the whole. The former easily eludes us, but in truth, it is largely veiled by our own inadequacies of visual understanding. No work of art lacks this quality whether it be feeble, moderately successful, or a rare perfection. If we are unable to describe precisely the nature of the total form in Michelangelo's drawing, we sense it to be a perfection, a consummation of all the parts in their specific relationships one to another. And the whole *is* form.

In several other drawings by Michelangelo, the same compositional elements are found (two mourning figures, the crucified Christ, and the cross composed within vertical formats of somewhat different proportions); thus all share the same general form. Nevertheless, because of differences in positioning and gesture, often subtle, each drawing projects a unique weight and feeling in its variations. Were each figure drawn exactly alike in all the crucifixion drawings, even so modifications of relationship between the figures would define significant changes in the total form. What this means is that all factors in a drawing determine the specific character of the integer and any change will modify it.

Total form can be described also as the *illusion* of a drawing. By illusion we mean the appearance or effect a drawing generates that contradicts the material flatness of the drawing surface. A draftsman makes several marks on paper, arranging them in a certain way, and, whether we would describe what he creates as naturalistic, cubistic, or abstract, the configuration of marks forms an illusion which alters in effect the two-dimensionality of the bare paper. This new virtual effect transcends the actual material fact, and is itself the total form. In Michelangelo's drawing the agony of the crucifixion is far more real to us than the physical materials from which the image arises.

Figure 4
Leonardo da Vinci, Italian, 1452-1519.
Deluge, black chalk, 6⅜ × 8⅛".
Collection of Windsor Castle.

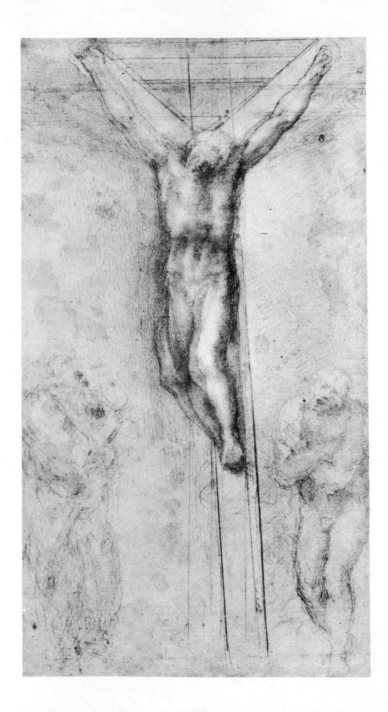

The terrible burden that weighs upon the cross draws to itself the entire energy of the total form, recharges this energy through its sculptural mass, and radiates an infectious power back into the whole. How concrete the Christ form, and yet this does not diminish the other elements to formlessness. Clearly the Christ is the most fully realized form in the sense of seeming to possess a feeling of three-dimensionality. Still the lower figures are forms, forms becoming sculptural; the cross is form, a structural form dividing the composition and heightening the humanness of the figures; and the surrounding space is form, a counterform carved into the paper by the suggestion of soft strokes of black chalk. Only the quality or kind of form distinguishes these elements; not that one obtains form and another does not. The idea that the term means only concrete three-dimensionality should be discarded, for, as we see, there are gradations of definition. Within Michelangelo's drawing these "gradations" of form exist in vital counterpoint.

Every artist redefines form. He arrives at his own conception directly through his work, but with a perspective of the history of form and an awareness of current ideas. Such contrasts of individual conception are necessary to the vitalization of art. Amadeo Modigliani differs markedly from Michelangelo. *Portrait of a Woman* (Figure 6) is much flatter than the previous drawing; it depends more upon line and less on tonality—it is a spare drawing more accessible to our immediate understanding. Our eye is quickly engaged by the abstractions of line which evolve an image of a human presence almost hypnotic in countenance. We identify with the moving pencil curving across the paper, bearing down, turning sharply, lifting, and moving again rapidly, but with surety and zealous purpose. The quick spirit of gesture —the pleasure of making—seems to be in our own hands; we move the pencil and turn the line that follows the ovoid of torso, breast, head. The sensation is double because we imagine ourselves both generating the abstract line and confronting the seemly model. Modigliani's forms are personal translations of sensual experience. His understanding and feeling for

Figure 5
Michelangelo Buonarroti, Italian, 1475-1564.
Christ on the Cross between the Virgin and St. John (c.1555),
black chalk, $15\frac{3}{4} \times 8\frac{5}{8}''$.
Collection of Windsor Castle.

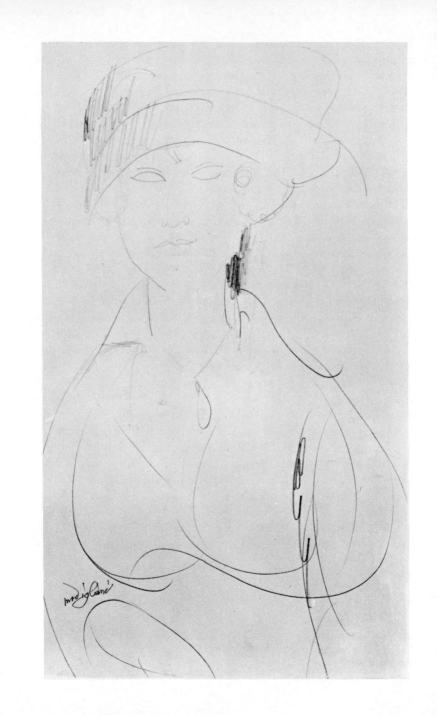

drawing, the language of translation, directly affect his transmutations of the actual form he sees before him. Voluptuousness of woman becomes sensuality of line. Line both translates and transforms. The forms that arise between these lines are the creation of an idiosyncratic vision, a binding together of a personal sense of gesture and an individual response to experience—Modigliani's own equation of drawing and seeing.

An object seen and its image projected on paper: the nature of perception and projection, the form of the image; here lie a multitude of questions. The most common—*how* does one form an image on paper? Numerous texts have been published on the supposition that *how* is the primary concern. Perhaps so. A draftsman profits from learning to draw the volume of an egg in chiaroscuro in the same way as a writer from learning to compose clear expository sentences. But learning methods of form-making seems hardly more important than realizing the interrelatedness of every element in the total drawing organism. For instance, before considering Modigliani's method we must sense the nature of his vision and the ideas that involve him in the drawing. First the work as a whole; then we may scrutinize it to discover that he achieves the suggestion of rounded breast with a full curve of line that tapers and lightens at either end. The more we examine the more we see that the sense of form depends on the pace of line, its fullness, tonality, comparative length, and so on, and the openness of the surface space. To understand the vitality of Modigliani's forms, or those of any draftsman, it is necessary to probe further than "technique."

<p style="text-align:center">❖ ❖ ❖</p>

Form embodies expression. To express is to manifest thought, feeling, or emotion. This cannot be less than the primary dimension of all art, all language, as necessity of expression seems to be the prime motivation in the creative act, or so we have often been told. What does drawing express peculiar to itself? In fact, what does drawing express? A drawing expresses what it has formed: experience. Drawing acts as a means of enlarging vision leading toward an apprehension of feelings, emo-

Figure 6
Amadeo Modigliani, Italian, 1884-1920.
Portrait of a Woman (1914-18?), pencil, $19\frac{3}{8} \times 11\frac{3}{4}''$.
Collection, The Museum of Modern Art, New York.

tions, perceptions, that can be arrested from experience in no other way; and it tries to project an understanding of these. Drawing is a way of living in the intensity of experience—this we consider the singularity of graphic expression. If we find it more so than for painting or sculpture, that is because of the immediacy and directness of drawing.

Words are our common and convenient means of expression, yet often the richness of experience lies beyond their reach. Ordinary language, at least, can falsify, bind, or dilute the immediate qualities. Not that drawing entirely escapes these difficulties. Its directness, however, enables the sensitive draftsman to encompass a vital share of both objective and subjective experience. For those who believe experience, if expressible at all, can be given form by any or all expressive means, this seems only a specious argument. Neither argument nor defense, it is a point of view experience itself has proven out. Vernon Blake, an English artist who wrote a sound and somewhat anomalous volume on drawing in the early part of this century, supports this judgment:

"Each art exists because the ideas special to it cannot be transmitted otherwise. . . . The plastic arts have a logic, a rationality of their own, which cannot be transmuted into the terms of verbal ratiocination, nor even into a form of non-verbal reasoning, applicable to other types of mental activity." *

"Drawing is a loose term to which we must accord at least two meanings. It consists first of all in a perfect comprehension of the structural nature of objects; and secondly in the power of expressing thought and emotion by means of writing down of such structural nature." **

Although Blake implies a much stricter conception, we are essentially in agreement. Each art exists because of the qualities special to it, and this lends a uniqueness to the expression it materializes.

If drawing were a lesser craft, the fierce spiritual struggle which is the substance of Michelangelo's *Crucifixion* series would not saturate these few small sheets. Yet they do exist and in themselves are sermons on the capacity of drawing expression. Michelangelo's dialogue with the Cross was sustained through all areas of his art, if only to affirm his personal inquietude and pain:

* Vernon Blake, *Art and Craft of Drawing*. London, 1927, p. 394.
** Blake, p. 30.

Neither painting nor scultpure can any longer sooth
My soul turned to that divine love,
*Who opened his arms upon the cross to take us.**

Although the visual arts in this late period of his life may have failed to bring quiet to his soul, we know that Michelangelo did not cease to express himself through them. Nowhere does he give this image more poignant urgency or greater reality than in this series of drawings. Through their making Michelangelo clarified the form of the Blood and the Cross and moreover drew their meaning deeper into his spirit. Can we not say that as these symbols appear in the sonnets we are aware of the tumultuous power they possessed for him, and that as they are found in the drawn forms we are struck ourselves by the immensity and meaning of the event?

<div align="center">◇ ◇ ◇</div>

Tradition holds that a drawing is a personal expression, a private affair. The relation between artist and materials, artist and object, artist and idea has always been an intimate one; particularly so for the draftsman because what he creates in most instances is strictly for his own purposes. For the greater part, while studying from a model or recording the mind's visions, the draftsman frees himself from the demands of a public statement. There are many examples of less reputed artists who show a comprehension, daring, and virility in their sketches which in their formal work seems to be either missing or buried in a heavy wax of conventions. It is a requisite of connoisseurship that one recognize and treasure the intimate quality of drawings as though one were allowed to steal unnoticed into the creative mind and observe its workings. Unfortunately this notion has become somewhat of a myth; we should therefore remind ourselves that drawings are not wholly private. In this century especially, everything seems to be dragged from the studio, often with the encouragement of the artist, and the private becomes public. There are at least three kinds of drawing that cannot be classed as private, though like any work they may be intimate. The first is the spurious drawing either designed consciously as a virtuoso deceit of market value or as a self-conscious attempt of the artist to dress himself in all the virtues of master draftsmanship. In the latter case the artist becomes victim. He falls into false showmanship because he does not

* From Michelangelo's sonnet, *Giunto è già 'l corso della vita mia . . . ,* translated by Charles Russell.

ignore his audience, be it his master, other artists, or the art public at large. Unwittingly he draws for them, for their expectations, not for himself. The intentional counterfeit probably came into being straight on the heels of the first sale of a master drawing. These drawings need not be forgeries or the like; they are simply salable items disguised as pages from the inmost world of the creative personality. Rather than a private dialogue, they are a private enterprise. A second variety of non-private drawing is the presentation drawing designed specifically for a given audience either to present a proposed project (for example, architectural renderings) or to display a proficiency in draftsmanship. These, too, might suggest a falseness in their self-conscious intent except when one realizes how common it has been in the past for painters and sculptors to submit their ideas to patrons in the form of drawings. And, whenever an art institution places great emphasis on drawing, students have been required to present their level of graphic competence. We need only think of the studies Leonardo submitted to his patron, Ludovico Sforza, to realize that presentation drawings may attain the highest level. There are also sketches by a master given over to his workshop to execute as commissioned paintings, or simply as instruction for his apprentices.

Even at this, drawings do not necessarily sacrifice their personal, intimate character. It seems largely inherent in the simplicity and directness of the graphic language that drawings should always retain a certain openness and informality, which perhaps keep them closer to the creative vortex.

Theories about drawing have varied on issues over the past five centuries, new attitudes have arisen, yet none have really outdated themselves; in large they add to one another, focusing on drawing as a basic discipline, a unique fusion of perception, idea, and material means. If an attitude can be discerned as distinctive of the last 100 years, it would be the notion of drawing as a form of expression complete in itself. The autonomous drawing, the third variety of non-private drawing, is not a recent phenomenon; it evolved slowly from the ideas we find in Pisa-

Figure 7
Odilon Redon, French, 1840-1916.
The Accused (1886), charcoal on sienna paper, $21 \times 14\frac{5}{8}''$.
Collection, The Museum of Modern Art, New York.
Acquired through the Lillie P. Bliss Bequest.

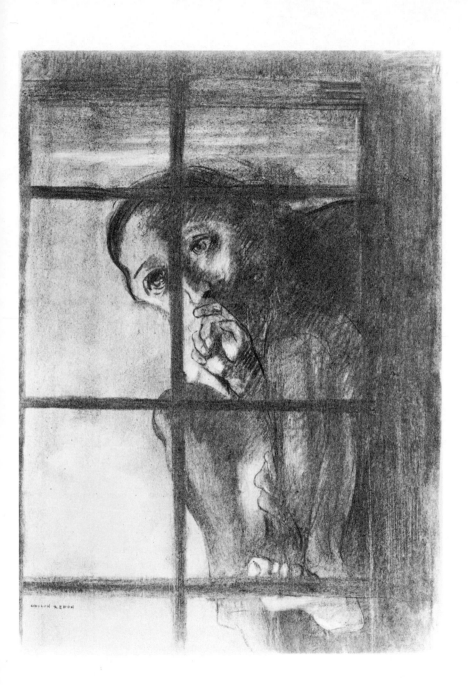

nello, that is, the deep satisfaction of graphic study or expression for its own sake. Such independent, contained works are found through the whole of modern drawing: Breughel, Michelangelo, Pontormo, Rembrandt, Clouet, Guercino, Canaletto, Goya, Blake, Fuseli, Ingres are all draftsmen who produced drawings that may be considered essentially autonomous. The difficulty is that the intention of the artist—whether he intends a drawing as a final expression—determines if it belongs to this "category," rather than our sense of its completeness. Many great drawings that we feel stand on their own aesthetically are no more than fragments to the artist.

Toward the close of the nineteenth century autonomous drawings became increasingly frequent and accrued an even greater fullness of expression. Odilon Redon's graphic work represents what amounted to a transvaluation of drawing. Charcoal on paper, for him, was in itself mysterious. The strange creature who taps at our mind, *The Accused* (Figure 7), appears to be an image evoked from Redon's imagination by the dusky tonalities of charcoal; and it stands as final expression, even if an elusive symbolism and occult imagery. Would this vision of such soft tones on sienna paper be any more compelling, any more a full quantity, were it oil paint on canvas? No. Differences would appear, but differences in quality, not in the degree of expressional manifestation. Redon's drawings contain their thought completely. One may puzzle over their abstruse, subjective meaning; at the same time it is clear that the resolution of the drawing's significance lies entirely within the shadows of the page.

At this point the issue of privacy or non-privacy seems irrelevant in the realization that drawing has come to attain the stature of a major mode of expression. Expressional completeness gives us the final complement in the total organism of drawing.

<div align="center">◇ ◇ ◇</div>

To suppose drawing may be defined is surely praiseworthy. But even this brief inquiry has opened many passages into a broad landscape that ranges beyond definable limits. What we have accomplished is to investigate several areas of concern which are essential and coequal dimensions of drawing. The act of drawing is one of mobility, of penetration, of measurement, of sustaining perception and directness; not rhetoric, not grandiloquence. Indeed, at some of its greatest moments drawing may appear rude and graceless, a form of plain speech. In Lovis Corinth's self-portrait (Figure 8), we have the unusual experience of

Figure 8
Lovis Corinth, German, 1858-1925.
Self-Portrait (1924), black crayon, $12\frac{1}{4} \times 9\frac{3}{4}''$.
Courtesy of the Fogg Art Museum, Harvard University.
Gift—Meta and Paul J. Sachs.

becoming the mirror of the draftsman's stare. Hard and firm and piercing, he probes the psychological surface of the mirror, penetrating it with eye and crayon. We witness the intensity of the act and imagine the performance played out: stubby, ineloquent marks molding an irrefragable image from paper.

What can one really say about drawing? It awakens our numb vision. It is a nourishing force. It is, so to speak, an indictment to look. And drawing defined as an artifact: the product and the symbol of the act of drawing.

TWO

Drawing as Seeing

Ordinarily we do not make full use of our faculty for seeing. An expeditious, computer-like response to visual stimuli is the normal mode; we react automatically, selecting from the numerous signs that crowd and demand our attention only those which provide information pertinent to our momentary needs, and very little else. Not to exceed this mean level is, in effect, to suffer from visual poverty. We are aware that a tremendous quantity of knowledge can be gathered through direct visual perception, the act of seeing. And yet this is the apposite fact: we look, but we do not see. So much escapes our perception, either due to indolence, or because of our preoccupied thoughts, or simply because our visual sense has not been disciplined to more active and substantial use. Drawing is a discipline of vision. It heightens perception. Drawing = seeing, as we have already said, but the nature of the equation is complex and elusive; the complexity is compounded by misconceptions and the elusiveness increased by the ambiguity of words. Seeing is the act of perceiving with the eyes; to look is to direct this faculty. To look for, to seek meaning in experience is the cogent and unyielding task of the draftsman, requiring every capability he can marshal, above all a state of complete awareness. Complete awareness: no one can really judge what this should mean for the individual artist.

We can only picture the confrontation in generalities; as a contest in which vision becomes intimate with every aspect of mind, drawing is the field of struggle, and understanding the goal. Without full participation, awareness, and responsiveness, the contest is a hopeless pantomime, no matter how brilliantly performed. The profile of reality can only be drawn by a line traced from deep within the intelligent eye.

The intellectual act is one of seeking connection, and to draw is to seek connection. Drawing and intellect—most twentieth-century artistic theory stands at odds with any reference to intellect, or is at best suspicious; yet a very real relation exists. Intelligence attempts to give an order to experience and does so by means of a discipline which by nature is ordered—language. Language allows us to communicate and express; but before that, it clarifies, connects, and forms thought. Drawing does the same. The first function of both is precommunicative: to sharpen perception, to clarify it, and to give it an ordered form. Not until perception and thought are clear in our minds can we communicate anything but addlemindedness to others. Drawing as the fine instrument of vision centers its initial effort on the draftsman's own understanding of his experience. The connection between the various fragments of experience are what drawing seeks. Ordinary sight defines shapes—names objects—but recognition is no more than the mean level of awareness. The kind of seeing that cuts through isolated objects to search out the evasive relation between them, that penetrates the surface of appearances to discern an internal structure beneath, is our concern.

General remarks are deceptive. In this case we must not overlook the infinite shades of interpretation which individual personality and sensibility bring to experience, nor the layers of meaning which the word *experience* itself possesses. Generalities reveal their appurtenant meaning only in the specific instance where we see them through the perspective of an individual personality. Line mediates a silent conversation between the draftsman and the currents of his experience. The draftsman attempts to maintain a condition where the senses meet directly with reality, where past experience and preconceptions assist but are not substituted for fresh examination. He seeks the structure of appearances, relatedness, and order. Whatever meaningful order the draftsman determines will be as singular as the individual himself; how significant it will be to others is, of course, another question.

<div align="center">❖ ❖ ❖</div>

Between 1906 and 1910 Piet Mondrian, a man who would come to "abhor" nature, produced a series of thirty-three studies of chrysanthemums. These extraordinary works in various media well exemplify drawing as seeing. Collectively or singularly they represent, in a way more easily grasped than in Mondrian's later work, the artist meeting reality empirically, determined to apprehend that reality in mind and on paper. The drawing reproduced (Figure 9) is one of the strongest and most fully developed of all, yet to isolate it is partly injustice, for the group as a whole gives an overwhelming sense of the kind of intense inquiry of which Pisanello and Leonardo are the first masters. Expression in the form of a very faint and delicate Rilkean poetry hovers gently in these works, but is dominated, as is the tendency toward the hyper-analytic, by the actual physical presence of the flower.

A chrysanthemum is a complex tangle of petals bushing out from the core, the blossom appearing to be a nearly patternless mass. The petals are the same except for tendencies to curl, fold, bend into their own peculiar form, as do the intricately shaped leaves, here drooping and wilted into a second, more complex mass. Visually untangling such an object in the mind to the extent where Mondrian could construct its parallel in drawn line demands an intensity, understanding, and persistence equal to the devotion that nurtures the plant into blossom. And how much more impressive when the examination has been sustained over several years, returning again and again in numerous studies to grasp all the stages and variations—blossoming, wilting, dying. The intensity of focus in this particular drawing, the extent to which it exceeds a cursory representation, is perhaps its most extraordinary quality. A clever draftsman can produce a satisfying image which "looks like" a chrysanthemum without really comprehending what he sees; his pencil can record light and dark patterns as thoughtlessly as film in a camera. Mondrian transcends easy mimicry. He follows each petal, each leaf, traces its connection and form, feels the totality, and defines the parts through the structure of the whole as though he were actually molding his own flower. He creates a reality as convincing as the chrysanthemum itself. Such comprehensibility could only come from an eye engaged by every turn and nuance, by a mind possessing a sense of the entire plant.

The drawing reveals more: an understanding of the graphic means that equals the eye's penetration of the object; the two are necessary complements. Mondrian found in the nature of his means, the language of drawing, a parallel to what he experienced as the form of the object.

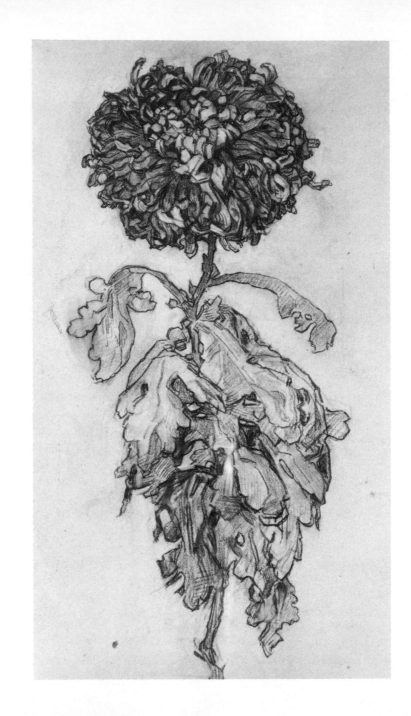

The marks themselves do not deny their material origin; they instead transmute the reality of chrysanthemum into the substance of charcoal and paper. If a drawing diagrams experience while leading this double life, it deserves our most profound respect.

Most of us are capable of drawing a series of lines that could be read as *flower*, representing a generic conception. Very little knowledge of flowers is necessary either to produce or decipher such a symbol. A child does so with ease. Given the unique form of a specific flower in a particular organic state, however, and the pictogram no longer applies; we must now, like Mondrian, struggle with the specific instance with all the force of direct sensuous contact; the flower must be held and examined, every quality felt by the eye and hand. But the inchoate line of a novice draftsman will fumble along the outline, unsure and hesitant to wrestle with the actual complexity of the object, searching for the reasurrance of an easy pictogram, his eye overwhelmed. Rather than meeting the object head on, there is a strong tendency to rely on previously formed notions. We have preconceptions about how things should be seen, what should be looked for; but most restricting, what a drawing should look like. And this is so to the extent that the student often seems more involved in pencilling his conception of a drawing rather than shaping what he sees before him. Unfortunately this is not true for the novice alone. Prejudices and preconceptions block an artist's growth when he allows them to limit his responsiveness or to predetermine the outcome of his efforts. However, it would be itself naïve to suggest that drawing should be approached naïvely. Preconceptions of a kind are pragmatically necessary lest we stand amid experience like cows; but these preconceptions must function to help form questions, to aid the dialogue, never to substitute as answers.

One must be cautious of accepting another artist's method of formmaking and wary of instruction directing one How to Draw. To accept another's technique is to accept also his way of seeing. The methods must grow from one's own vision—style is a manifestation of an individual spirit. Of course we learn from other draftsmen. Mondrian's drawing inspires. His achievement may urge us to a fuller effort, the

Figure 9
Piet Mondrian, Dutch, 1872-1944.
Chrysanthemum (1908-9), charcoal on gray paper, 23 × 13″.
Smith College Museum of Art.

drawing can guide and instruct as we unravel its workings; but we must assimilate these qualities naturally into the stream of our own artistic personality. The lesson here lies not in the manner of drawing; it is the depth and relentlessness of observation that we can profit from, for then the surface qualities are understood as the necessary means of an individual vision. What Mondrian sought was the internal design of a natural form. The configuration of parts is unfolded by firm strokes set down with such surity as to transform transient fact into a monumental permanence not unlike sculpture. In a later series of tree studies, he pushed the process one step further. He traversed the isolated concreteness of the object in pursuit of a rhythmical structure and the relational laws of space concealed within its architecture. The process always proceeds from the specific. We see in the chrysanthemum drawing this necessary beginning: a complete concession to and celebration of the object. Mondrian begins to measure the universal by examining the particular, with lines that converge on the object as if to wrest it free from confusion.

<div align="center">◇ ◇ ◇</div>

Vernon Blake states that, "We are all willy-nilly, consciously or unconsciously the artistic children of Cézanne." * Certainly it was true for Mondrian. The intense devotion to the phenomena of experience which *is* Cézanne became Mondrian's unembellished inheritance. Cézanne, however, is much more difficult, particularly in regard to his draftsmanly vision, for his drawings and watercolors explore not only visual phenomena but also the phenomenon of vision. He is supremely aware of the object and its existence as affected by relational forces—as well as the tensions worked by vision itself. The key to his drawings (as in all his work) is his special recognition of the contradiction between spatial reality and the flat picture image. His attempt to resolve the two results in an often enigmatic configuration of nervous marks which are stated and restated in order to affirm the sculptural reality of the whole. Cézanne's unique perception seems to have led him intuitively to a concern with the relation between visual sensation and cognition. The drawing is the plotting ground for his struggle to realize the problem as he envisioned it. Because of the complex and original nature of the struggle, his drawing at times appears quite awkward. The palatable finesse of virtuoso draftsmanship proves poor equipment for

* Vernon Blake, *Art and Craft of Drawing*. London, 1927, p. 9.

the original thinker; and pictorially, Cézanne possessed a fierce intelligence.

Condensed into Cézanne's drawings, such as that discussed in Chapter Three (Figure 22), are the patient examination of his natural subject and an intuitive study of the pictorial language that becomes reduced to its skeletal form in his pencil and watercolor drawings. He is the philosopher simultaneously engaged by the essence of his thought, the process of thinking, and the logical syntax of the language by which he forms and records his thoughts.

<div align="center">◇ ◇ ◇</div>

Unlike both Mondrian's and Cézanne's, Rembrandt's drawing was not directed toward the patterned world of solids and fixed relations. In these remarkable drawings the transiencies of two worlds live side by side: the first, external, but more fluid and animated than Cézanne's; the second, internal and visionary. Rembrandt's work exists at the edge of these two.

How Rembrandt applied his draftsmanship leads us immediately to his immense capacity to absorb dynamic experience. The static docs not exist; the entire environment pulses, everything performs with a very real sense of life—this is the impact of his drawings. There is a kind of animation and characterization here not to be found in previous draftsmanship. When we try to determine what the kind is, the answer seems to be that Rembrandt possessed an unequalled sensitivity to human gesture. The attitude of every acting element in any of his sheets reveals a complete empathy with that element. Claude Roger-Marx (and Otto Benesch) considers the dynamic factor to be *light*. The very real light and shadowed ambience which fills and presses against Rembrandt's forms is a vital force and perhaps the source of "mystery"; yet, M. Roger-Marx is mistaken in judging it the *prime* factor. Reality of light, of movement, the energy, the life force are born from an acutely sentient eye which tenders and equates the very human gesture with every gesture of the drawing hand. Every scene whether it be a tavern brawl or *Pilate Washing His Hands* (Figure 10) possesses the immediacy of on-the-spot accounting. Moreover, we participate. Rembrandt's vision is so complete that one is unable to distinguish a strict division between external observation and mental conjuring. The play of his imagination he envisions as reality, and the real he so easily transforms into his imaginary world. Both are absorbed to culminate in the drawings.

<div align="center">31</div>

As a draftsman, Rembrandt supplied his memory, providing that storehouse with a record of moving life and fleeting thoughts to be drawn upon as needed. A poignant observer, alert to human attitude, he avoided the artificial conceit and mannered formula in order to find his crowding life experiences the real source of invention. Is it not reasonable to speculate that drawing was for him actually participation in experience?

In succinct fashion we have examined variations on the drawing-seeing equation. That an original and causal relation exists should become clearer through examples. So far our consideration of the drawing experience has dwelt on perception of the physical environment; likely enough, since as our common share, drawing is naturally directed to it. For the artist, without the visible the invisible cannot exist; without daily visual encounters he is unable to envision. Rembrandt proves the case. He also provides a transition for us into a second phase of the subject. How very apparent it is that he staged his imaginings on the foundation of daily experience.

<div align="center">◇ ◇ ◇</div>

The great visionaries, as well as more empirical artists, have found drawing to be the forming tool of their imagination. With it they are able to seize the conflux of vague, yet insistent images that exist in their minds. At the furthest extreme these become the convoluted diagrams of private visions; at a point closer to the ordinary, they are diagrams of an idea. Whether the imagination is practical or fantastic, drawing renders an essential service to its invention. Any notion which is visual in nature (in fact, possibly any notion at all) conceived in the mind may be given concrete form through drawing. Generally the process is one of evolution. Blurred mental images, once projected onto paper are immediately given a new identity by line. The original idea may now be judged by the eye, developed, and resolved if resolution proves possible—altered or discarded if it does not. Essentially this is the same as drawing directly from experience, except that the model

Figure 10
Rembrandt van Rijn, Dutch, 1606-1669.
Pilate Washing His Hands (c.1650-55), pen and bistre, 8 × 10$\frac{1}{4}$".
Courtesy of the Fogg Art Museum, Harvard University.
Gift—James N. Rosenberg in honor of Paul J. Sachs.

exists in the imagination only, and rarely in precise form. The burlesque sepia nightmares of Goya, the mechanical "Icarus" envisioned by Leonardo, Van Dyck's summary studies for an Entombment, the architectural visions of Gaudi, Henry Moore's monolithic sketchbook figures bandaged in line—all are examples of plotting the course of an idea by drawing it out. Regardless of the level of artistic vision the function is of extreme value to the individual artist and, in large part, is probably the most frequent application of drawing. Rather than being an inquiry directly into our environment, it is an investigation of the terrain of the imagination. The sketchbook is thought of as a journal; in this instance, however, the drawing does more than record. It shapes the shapeless, allowing an idea to be worked, to mature. A measure of concreteness is achieved in the transposition of a mental image to paper. And there to be put to test.

To reiterate: the half-formed images (frequently no more than chimera) that play within our brain may be seized and educed by approximating them in line and progressively bringing them to clarity and completeness. Invention may, however, require more from drawing, for at times the imagination must be actively incited to create.

<div align="center">◇ ◇ ◇</div>

*A New Method of Assisting the Invention in Drawing Original Compositions of Landscapes** is the wonderful title of Alexander Cozens' eccentric essay written in a century (published in 1785) that had a great attachment for artistic and quasi-scientific theorizing. Although his concern with ideal landscape is no longer a vogue, there is in his writing a great deal appropriate to our subject. Cozens' text is not unlike his "Method," in that considerable room is left for interpretation or misinterpretation; he has largely been victim of the latter. The object of the essay was to present a method whereby the individual would be aided in discovering for himself fresh compositional constructions. Cozens devised a system which he called "Blotting"—a choice of word that leads us immediately astray. Actually a "Blot" is a broad and hasty brush drawing which is accidental in its parts only, the total design being guided by a general conception. "Possess your mind strongly of a subject."—the implication of pure chance is erroneous. This is doodling with purpose, not automatism, as generally interpreted; in other words, there is a controlling factor, other than the subconscious, which is the determining will.

* A. P. Oppe, *Alexander and John Robert Cozens*. London, 1952, Appendix.

The Blot is not a drawing according to Cozens, "but an assemblage of accidental shapes, from which a drawing may be made. It is a limit, or crude resemblance of the whole effect of a picture. . . ." "To sketch is to delineate ideas; blotting suggests them." Our understanding of the *New Method* may be described in this way: The draftsman (blotter) begins with some general notion such as a low flat landscape dominated in the central foreground by a large tree. Guided by this pattern he rapidly executes with broad brush and ink a very free series of marks or "blots." The individual characters are "rude and unmeaning," the mind remains on the whole of the design. Interpretation of the blot is the second stage, which may be carried out on the same sheet or transferred to a second, and being entirely without precision, the blot permits several readings. Finally the artist delineates his interpretation, taking care to articulate all the constituent parts and reduce the initial ambiguities. The culmination may still be a long, low landscape dominated by a single tree; but hopefully the mind has been freed from the stereotype to uncover fresh variations on the theme.

Cozens' "blot" is a device. And we are rightfully wary of both devices and systems. There is, however, real merit in the *New Method*. Its ideas are not foreign to us; in fact they seem faintly to portend many aspects of twentieth-century picture-making, particularly surrealism. A quiet and moderate revolutionary, Cozens was in his own way a sentinel of poetic imagination. The singular purpose in dwelling on him is that he directs our attention to issues relevant to drawing and vision.

First, he says that the method "is extremely conducive to the acquisition of a theory . . . ," and "this theory is, in fact the art of seeing properly . . ." For Cozens the art of seeing properly involves strong conception, selectivity, connection, precision of meaning, and above all a sense of nature. The entire essay is a mandate against the then common practice of copying other men's inventions; at the same time he did not have absolute confidence in copying from nature. It would seem that he felt one should study and absorb nature intently. From direct contact certain general principles might be discerned and particulars would be absorbed into the memory. Creative invention occurs for him, not before the individual nature, but in a circumstance where recollections and associations might be brought forward from memory spontaneously and with spirit. The artist is grounded in nature, in the wealth of perceptual experience which surrounds him—here he begins to see. Vision is something further, a power delivered from the substance of the individual himself. Cozens' method was designed to facilitate drawing this forth.

The second fact of considerable importance is Cozens' emphasis on the *total* design. What a marvelous remedy, the *New Method,* for those who see only minutia, ". . . for in making it [the blot], the attention of the performer must be employed on the whole, or the general form of the composition, and upon this only; whilst the subordinate parts are left to the casual motion of the hand and the brush." His scheme requires the artist to see the essential organization prior to all else. The absolute verity of this notion cannot be overemphasized.

Forty-three aquatint plates of blots and sketches accompanied the essay. These are probably better known than the text itself and have acquired for Cozens a good deal of contemporary interest, if not respect. The character of the blot being of uniform tone and without descriptive detail, it appears as a rather flat abstract design very much in keeping with the dominant twentieth-century pictorial aesthetic. There is nothing really important about this fortuitous fact except that it does imply an awareness of the essential integrity of the picture as pure design. From our viewpoint it is no longer necessary to continue Cozens' distinction between a drawing and a *blot.* A drawing may both delineate and suggest. But before all else a drawing is a collection of marks, lines, shapes, etc., of unique configuration made by particular materials. But what relation exists between formal conception and seeing? This is the question implied by the *New Method.*

Formal elements are those elements common to all picture-making. They comprise the form of the work itself, for example, line, shape, value, etc. Formal conception, then, refers to the way in which an artist conceives the function of these elements, how he operates with them. The materials themselves, pen, charcoal, paper, etc., are manifestly a part of the same issue. Although both of these—materials and their function—are examined separately and more completely in succeeding chapters, two points should be made which are implicit in Cozens' blot-method. The syntax of pictorial elements within the particular convention of the artist and the natural characteristics of his materials determine the limitations of the means. To a considerable degree these affect and direct vision. As an individual becomes conscious of the relational laws in drawing, he will begin to take notice of similar relationships in experience. The course of the stream moves both ways: experience in drawing—arranging line, creating form and space, relating parts, exploring various materials—will slowly act upon the vision of a sensitive individual, affecting how he sees, even what he sees. Conversely, natural experience, as the ability to absorb and to see is developed, will give insight into the internal nature of the picture. Cézanne indicated that

these are two worlds in consonance, running parallel to each other.

The second point concerns the changes that occur in the form of an image during the process of drawing, the *metamorphosis of the idea*. In Cozens' scheme, the draftsman begins with a general concept which guides him in making the freest sketch. He then responds to forms suggested in the resulting pattern and determines the final forms from successive interpretations. In other words, the results were not predetermined, only the method. It is possible to work in this manner by beginning the drawing with a fully developed idea or with no idea at all. What actually transpires on the sheet may suggest alterations, variations, or completely new directions. They may be the purely accidental mnemonic signs that draw associations and fresh invention from the fanciful mind, or half-resolved forms which in their ambiguous state provoke alternate possibilities. Whether the artist continues on his course or follows a new path will depend first on his awareness and second on judgment. He must be responsive to the actual events occurring before him in the drawing and willing to sacrifice the initial idea. If the artist is receptive to the free growth of an image he will allow the drawing to lead him, but at the same time will judiciously select, discard, or further build upon uncovered possibilities. The whole is a process of seeing. Though one be possessed of an idea, a vision, the final form remains indeterminate until the entire process of making is complete. If true, then as artists we do not really *see* until we have given concrete and integral form to an image.

<div align="center">◇ ◇ ◇</div>

Seeing. What does it really mean to a draftsman consumed by his task? Can words give the meaning of relentless vision? Phrases penetrate only so far into these drawings and the perception that lies behind them. If we are able to push closer to the vital existence of a work, it is our own acuteness of feeling, our senses heightened by the experience of the drawing that bring us here. Intensive draftsmanship sensitizes our vision. And as we approach the balance point of a graphic image, we may come to comprehend the weight of this word *seeing*. Kathe Kollwitz defines so much about human form in her study of the old woman (Figure 11). She sees the right arm and hand, the profile of thigh, the juncture of hips and upper body, the stomach's heavy projection with unequivocal clarity, and records them with a simple strength. Every undulation of line and shifting tonality conveys information about the constant changes of surface form. Charcoal becomes

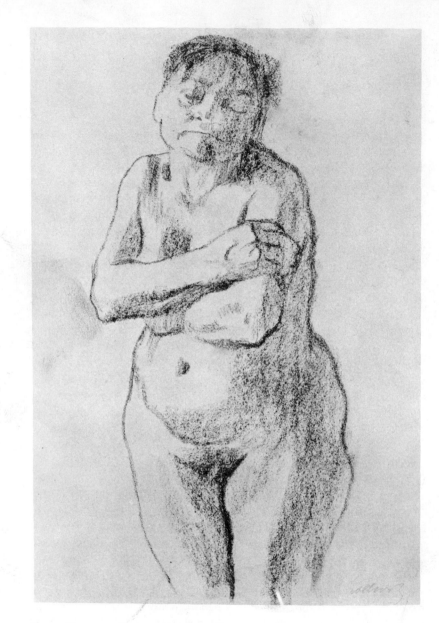

Figure 11
Kathe Kollwitz, German, 1867-1945.
Nude Woman, charcoal, $17\frac{3}{8} \times 24\frac{3}{4}''$.
Collection of Dr. and Mrs. Malcolm W. Bick.

flaccid flesh. A vivification of anatomy—but is this the substance of Kollwitz's perception? The right arm crossing her body to grasp the other stands out as the strongest statement in the drawing, a sign of tragic condition reflected in the shadowed passion of the woman's face. We see the body, as did Kollwitz, as a vehicle of passion, her flesh as an oppressive, fateful weight, and her nakedness as an exposure of human estate. The total expression, the woman's acquiescence to her state: is this not more a measure of what the artist's vision disclosed? Every poignant fact is an aspect of seeing.

Visual ideas are never born whole from ether. They are the consummation of complete participation in experience. By which we mean total experience, everything—visual and nonvisual, concrete and conjured, empirical and fantastic—that is the configuration of our lives. In order to apprehend meaning in our experience it is essential for us to *see*, and drawing is the instrument of an inquiring eye that teaches us to see.

THREE

The Form-maker

Drawing is an exercise of eye and mind, an intelligent act which a draftsman performs reasonably and with purpose. Such remarks seem in opposition to much of contemporary creative theory. Conscious rationale is considered by many to be a force which chokes expression and invention; and so it can. Those who in various ways consume his work are generally impressed to find the artist himself knowledgeable; but they are extremely wary if they suspect his work of intellectualization or erudition. In his essay, "Fear of Knowledge," * Edgar Wind considers the relation between other-than-art knowledge and artistic imagination. Although he does not find all aspects of an anti-intellectual view unjustified, he attempts, as we shall, to dispel any unreasonable fear of knowledge or intelligence in art.

A nonverbal intelligence is a form not easily grasped by those unaccustomed to its use. Yet, visual intelligence functions as the formulating mechanism in art. Ernst Cassirer implied an awareness of this when he said that "art is an independent 'universe of discourse.' "** A philoso-

* Edgar Wind, *Art and Anarchy*. London, 1963, Chapter 4.
** E. Cassirer, *An Essay on Man*. Doubleday Anchor Edition, New York, n.d., p. 194.

pher, deeply concerned with symbolic form, Cassirer recognized in the visual arts methods characteristically different from, but analogous, or parallel, to verbal discourse. Visual intelligence functions in a manner similar, but not identical, to the ordinary mode: it convenes upon the materials of the artist's craft, channels the motivating desires, directs the mobilized forces all toward complete realization of the visual idea. We commonly attribute imagination and intuition as the creative sources. Pairing these two is poetic, but unrealistic unless "visual reasoning" is somehow incorporated.

Perforce we would define creative activity as a union of imagination, intuition, and intellect. Taken in the broadest sense, visual intelligence *is* this union, and therefore the governing force that guides the artist through the myriad decisions between the first vague mental image and the final form of the work. The decisions involved in the development of a drawing concern the organization of the formal elements, their articulateness and logic, and the effectiveness of the whole in relation to the intention.

Experience is the leavening of art. The intelligent eye matures through exposure to full and rich experience, especially the compounded experience of making and studying drawings. By constantly producing drawings, the draftsman gains an understanding of his means. He is then able to respond to the visual problems that confront him with greater judgment and conviction.

An understanding of the pictorial means, a sensitivity to the phenomena of experience, a commitment to the enveloping motivation; these are aspects of visual intelligence. But attempting to unravel the workings of this intelligence will baffle the mind utterly. The processes are nearly inscrutable. It is an apparent paradox that a drawing is formed by visual intelligence, yet the processes are largely mystery: the greater the drawing, the greater the mystery. The visual mind can only be partly measured by words.

Academic is a negative adjective in art today because of a reaction against nineteenth-century art institutions. The word implies regulatory theory distilled from once-vital ideas and applied in a formal, pedantic method. Ultimately it represents a deadening force. But the academy, strangely, has been both the graveyard of ideas and the breeding ground for revolutions. There is in actuality no need for the nineteenth-century academy to continue as the whipping boy for mediocre art. We tend to forget that old academies are replaced by new

ones, and that now we are unquestionably possessed of a twentieth-century academy imposing its own formalisms, disguised under the well-worn banners of recent revolutions.

In any case, one fact remains undeniable: any artistic idea loses its strength once the dynamics of the idea have been slowed down by pedantry. Such impotency is the product of a kind of intellectualization, a treacherous "intelligence" of which we are justifiably fearful. From the "academic syndrome" there arises a mistrust of intelligence in art. We neither defend nor attack the academy; the issue is intelligence and intelligence clearly is a dichotomous force.

The mind can work against our purposes, cutting across the vital current of an idea, or it can sustain the creative flow. At least two varieties of imbalance may be responsible for the former condition. A sterile formalization, a kind of "over-think" is the first; and the second victimizes invention by substituting other-than-art knowledge for visual intelligence. Conscious reasoning is but one level of the mind's operation. Functionally it pursues order, countering confusion. But there is a tendency, unfortunately, for it also to control other, freer working levels of the mind by imposing a weighty network of rational thought. As we are well aware, the reasoned formula is a deadly instrument, constricting imagination rather than modulating it—which is the real function of the conscious mind. At its best, the conscious mind should provide a dynamic resistance which can actually propel the energies of imagination toward their target with greater accuracy and effect. We should insure that it does.

Knowledge and reason jeopardize creative vision to the same degree that they replace imagination. That an artist is knowledgeable is not in itself dangerous; but an inability to integrate his learning into the creative mechanism may undo his art. To be involved in other disciplines, to possess a varied body of knowledge, should extend and deepen understanding. It should provide sustenance for the inventive mind. Why, then, would it fail to do so? Other-than-art knowledge must be *transmuted* into the visual language of art. Any other method of union will prove to be only a marriage of convenience. The losses are too great; the result is, in Edgar Wind's words, "a hybrid of intellect and imagination in which art is sacrificed to the interests of reason and reason betrayed by the use of art." *

Admittedly, the problem of intelligence in art has been presented

* *Art and Anarchy,* p. 53.

only in outline. Even so, it should be clear that the fabric of artistic intelligence is a subtle, integral weave, threaded by imagination, intellect, and intuition, strong and mysterious. The fear of "academic" intelligence is not, however, without justification. But we should be cautious, not contemptuous; cautious of burdensome thought that oppresses or even diverts an organic growth in vision.

<div align="center">⋄ ⋄ ⋄</div>

"The process of drawing is before all else the process of putting the visual intelligence into action, the very mechanics of taking visual thought. Unlike painting and sculpture it is the process by which the artist makes clear to himself, *and not to the spectator, what he is doing. It is a soliloquy before it becomes communication."* *

Michael Ayrton's statement, quoted in acknowledgment of his sensitive writing on this subject, suggests a transitional question: What are the "mechanics of taking visual thought"?—What are the mechanics of drawing?

Drawing is an instrument of illusion. Lines, tones, and so on, on a flat surface are intended to transcend their physical identity to become a construction of form, movement, space, and weight. The drawing seen in this way is illusional, for in reality it is only a material fact, for instance, graphite and paper. All else is visual deceit. To the draftsman, however, illusional image and physical materials are equally real. The image is the thing. The materials are the stuff to be transformed. In concert they create an inseparable and consummate reality—at least, it is the draftsman's purpose to make them do so.

Articulated form is salient in all good drawing. It is the substance of illusion and the substance of our question as to what are the mechanics of drawing. What we mean by the phrase *articulate form* is the configuration of the drawing *in toto* as introduced in the first chapter. Space, movement, light, and plastic form are subdivisions of the total configuration. The anatomy of drawing, of articulate form, is constructed of the means: line, value, and so on. So much has been written about line: its geometry, varied character, and multifold uses; its appearance in design and nature; its history and "preambulatory" origin; and the ways of adapting it to any occasion. A proportion of this writing is misleading oversimplification offered the amateur with a proposal of "How

* Michael Ayrton, *Golden Sections*. London, 1957, p. 64.

to . . . ," even by correspondence! Some is esoteric theory. Between the obtuse and abstruse, there is a body of thoughtful literature to which we can add very little besides redundancy.

Perhaps like Paul Klee, we should regress to the *dot* and begin a description of the manifestations of line from there. Defined by Euclidean geometry, "a point [dot] is that which has no part," therefore no individual quality. Set into motion a point traces a line (Klee). Strung together dots also indicate a linear path. When massed and regulated in their intervals, dots may determine both linear and tonal pattern. Draftsmen and printmakers have used the dot in this way since the fifteenth century. We seldom recognize how common and how essential the dot is in drawing. Pen draftsmen employ dots to modify transitions of tone and for textural variety. But less obvious is the fact that nearly all drawings in dry media (chalk, crayon, graphite, and charcoal) rely on the dot to produce the effect of value. In this case the dots are not made individually by the point of a tool, but result from the chalk, etc., moving over a textured surface and leaving behind a broken pattern of small marks or dots. The proportion of white space to black dots within a given area equals a dark, light, or middle tone. Georges Seurat's drawings (see Figure 19) would be incomprehensible without this simple phenomenon.

A *mark* is the natural extension of a dot. Although the difference may be unnecessarily subtle, marks are distinctive because they possess an individual quality of their own. Minuscule shapes or abbreviated lines are marks. They serve as a middle variant between dot and line, describing texture, subtleties of form, or function as a change of pace in the pictorial design. In balanced use marks can lend richness to a drawing. Too often they add only needless minutiae and a niggling appearance. Van Gogh relied on dots and chiseled strokes and made of them the principal means of his draftsmanship. They became, in his drawings, the graphic equivalent, plastic and consonant, of nature's complex textures and forms.

Line is the characteristic graphic means. In pure concept a line is breadthless length (Euclid). A line possesses breadth as soon as it is made visible, however, and in drawing this becomes an important dimension. Length alone does not define line; texture, pace, width, tone-value, direction, and variations of these are all determinant qualities. As one studies good drawing it becomes apparent how much "information" these properties convey. One sees, too, that *variation* is an essential method of form-making. Varying a line—from thick to thin, dark to

light, smooth to broken, or straight to undulating—combined with the variables of interval gives coherency to drawing. The properties of line gain their graphic significance in the confluence of relationships of the particular drawing, and there alone. We can give them no meaningful definition outside the specific context.

To these graphisms—dot, mark, line—we add only tone-value and color. Color is an adjunct to drawing, albeit a frequent one; but as such, the more instrumentally color functions in a drawing, the more that work has departed from the conceptual base. Of course this is only a theoretical problem; generally the use of color in drawing identifies with that of tone—granting that a sepia or blue tonality has a different psychological effect than a gray. *Tone* and *value* are synonymous but ambiguous terms in the visual arts, both refer to the gradations of gray between white and black or the equivalent (light to dark brown, for example). Transparent washes, opaque paint mixed to a scale of tones, and controlled gradations in dry media are different means of tone-value. In a monochromatic photograph the tones interpret color and describe patterns of light and shadow. They can function this same way in drawing, or as an idealized scheme of modelling form, to suggest atmosphere and space, or simply as an abstract tonal pattern.

Hatching, series of short, parallel strokes which give the appearance of tone-value, was contrived in the early history of drawing as a simple graphic method of suggesting form. Depending upon the optical balance between thickness of stroke, its darkness, and the interval between strokes, the hatched area will appear dark or pale. (Mantegna's engravings and the pen or silverpoint drawings of Leonardo are superb examples.) To this elementary device may be added other layers of parallel lines crossing the initial hatching at various angles—*cross-hatching*. As the quantity of white space is reduced, the cross-hatching reinforces the chiaroscuro effect with a full range of darker tonalities. Because of the factor of a stroke's direction, hatching maintains an advantage over other tonal methods; it models form not only through light and dark, but also by indicating the direction of a contour surface. Albrecht Dürer took the method one step further and curved his engraved lines to the contour of his forms; as the surface undulated, the hatching followed the curve, giving a maximum description of the concrete form.

Hatching and its variants extend the function of line; with some media (pen and ink, engraving) there is hardly any other way in which tone can be effected, and so it has long been a common technique in both drawing and printmaking. Occasionally gradations of tone, as with

Seurat, become the sole means of a drawing, but this is comparatively rare. For the most part tone-value, however achieved, acts in consonance with a linear conception.

This briefly outlines the elemental vocabulary of the draftsman. It exists in infinite variation; the specific materials, the artist's purpose, and his personal interpretation of these elements create the variations. With them he shapes images of space, light, motion, texture, and plastic form; images born from his visual intelligence—his special way of seeing. As we have said before, generalities arise from specifics and in turn are given substantiative meaning in relation to particular instances. Let us then test these abstractions against good drawings.

<div align="center">◇ ◇ ◇</div>

Plastic form, space, light, and motion are very real formal concerns for all artists. The history of art is a history of changing emphasis and interpretation of formal issues, above all a history of individual visions. We are not to be concerned by chronology, causality, or irrelevant biography, only with the method and intention of the drawings themselves, and the qualities of the graphic mind they disclose.

A pure line curving sharply across white paper is elegant to behold. The simple conception based on this line—that is, the unadorned outline completely enclosing an object, isolating it from the surrounding space—is almost universally the elementary phase of drawing. In the hands of a draftsman supported by tradition and possessing superior sensibilities, the incisive, uncomplicated line can oscillate between ephemeral simplicity and complex expressive form. Picasso is such an artist. *Two Bearded Men Looking at a Giant Bust of a Woman's Head* (Figure 12) follows a tradition that reached its first height in the Antique vases and has been continued by classical draftsmen ever since. The drawing is in praise of abstract line, a superb example of what may be accomplished with the most limited of graphic means.

Nearly devoid of variation in width or tone and finely sharpened, Picasso's metallic line fairly vibrates in relief against the white page. Its limitation is its unremitting linearity. The frank and simple line is ill-suited to modelling space or volume; a line will adequately represent the edge of a shape more readily than the curve of a rounded surface. Plastic form, depicted solidly, requires ampler means. And yet, in contradiction, how sculptural is Picasso's drawing. The sense of volume we perceive in the figures and the space in which they exist are rendered by the most knowing suggestion. His intention, however,

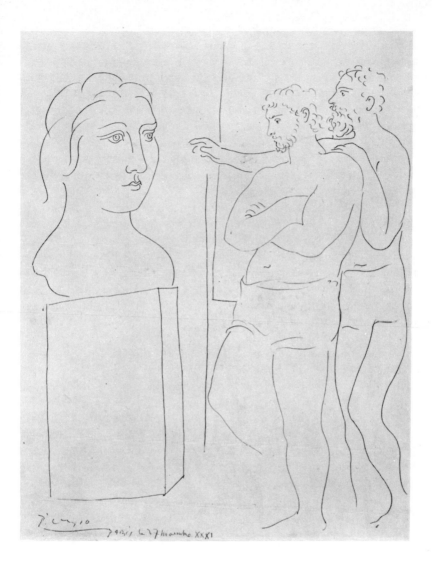

Figure 12
Pablo Picasso, Spanish, 1881 —.
Two Bearded Men Looking at a Giant Bust of a Woman's Head (1931),
graphite pencil, $13 \times 10\frac{1}{4}''$.
Collection of Curtis O. Baer, New York.

is not primarily plastic; surely less restricted means would have been chosen if that were the case. The intrinsic beauty of line and the private myth he pictures are together the subject. But his rhetoric is made convincing by the magical transformation of paper and line into sculpture-space-figures. How is it achieved? By a comprehensive knowledge of form, a sense of the natural gesture, and a thorough understanding of the power of line. In order to imply form, one must determine the essential clues; to select essentials one need possess a penetrating knowledge of form; to give line vitality one must have more than a cursive hand. Picasso's line is vital because it is an organic gesture tracing the edge of live form.

The secret of the achievement, apart from what we have already described, lies in the openness of the drawing. A line which rigidly maintains the periphery of an object will describe only its two-dimensional projection. In Picasso's drawing the line is not inflexible outline; it breaks, pauses, crosses and abuts, in rapid transit; our eye is given information at every intersection, and we conclude that these are volumes in space. We do so because Picasso selects the pertinent lines— but more, because he uses blank space prudently. The lines divide the surface in an "open" manner. Beside the pathway between lines, a "gate" is provided at almost every juncture, allowing the eye to move freely *in* and *around* the figures. This freedom of movement is an essential quality. Where lines do intersect they close the pathway at one end, defining a tighter connection. In only a single instance is an area entirely enclosed (the oblique panel of the sculpture's base). By utilizing minimal line and maximum open space the responsibility of completing the form is given over to us. We become more involved *in* the drawing. As we do, it is evident that the real significance eixsts in the finely sensed relationships. Picasso expands the limits of his unornamented means through more than optics. He elicits from our mind the understanding of our own experience and invites us to place it between these pencilled lines.

The *Kneeling Woman* (Figure 13), a retrogression in time of 400 years and a reversal to a more naïve conception, attempts to amplify the strict line directly by the addition of hatching and cross-hatching. Instead of suggesting or implying, the hatching specifies form. There are two distinct phases to the drawing: the line delimiting the exterior shape and subdividing the interior; and secondly, the hatched modelling, an adjunct to the line, which interprets the interspace as three-dimensional pattern. One qualifies the other, so that the drawing is neither

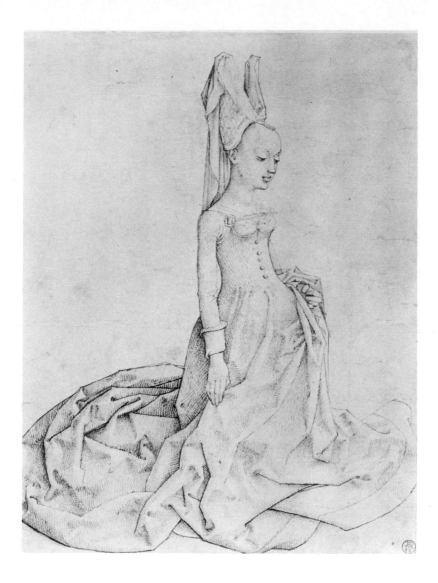

Figure 13
School of Hugo van der Goes, Flemish, 15th Century.
Kneeling Woman (c.1490-1500),
pen and brown ink, $9\frac{1}{2} \times 7\frac{5}{16}''$.
The Pierpont Morgan Library.

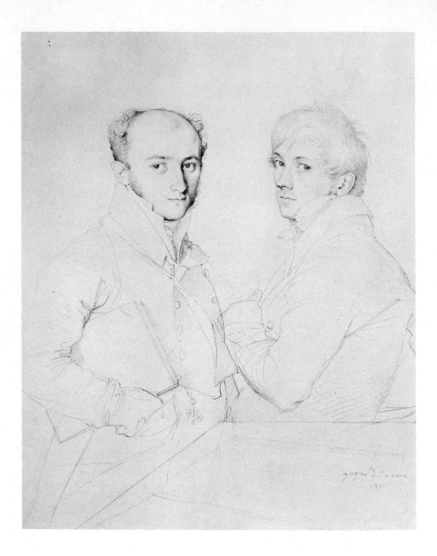

Figure 14
J. A. D. Ingres, French, 1780-1867.
Portrait of Leclèrc and Provost (1812),
graphite pencil, $12\frac{3}{8} \times 9\frac{5}{8}''$.
Smith College Museum of Art.

entirely flat outline nor plastic form released from outline. The fact that the figure is sharply closed off from the surrounding space supports its flatness. On the other hand, the effect of modelling is strengthened by the varied weight of line, reinforced in the shadowed areas, lighter or broken elsewhere. The overlapped folds have been subtly patterned to lead the eye around the base of the figure, or up and over the left hip; and in the horned headdress, as well, overlap implies dimensionality. But the suggestion is always contained by an insistent outline.

When we compare the *Kneeling Woman* to Ingres' double portrait (Figure 14), the earlier drawing seems to be derived from a schema that replaces a close study of natural appearances. The folds in the gentlemen's sleeves were interpreted from fact; whereas the folds of the woman's gown are a convention, a system of drawing based on generally observed laws of draped material. Her slight figure, though it exists convincingly beneath the garment, suggests an interpretation of anatomy not unlike that of a doll. Beautiful nonetheless, her beauty may be just this ingenuousness that closes her off from the world of Ingres or ours.

Although a Neoclassicist, Ingres was less prone to idealization of form in portrait drawing than in his nude figures, where he sought a surer perfection. In contrast to the unknown Flemish draftsman who created the *Kneeling Woman,* he appears as an out-and-out realist; but like him, Ingres stands only an arm's length from pure linear drawing, extending his means in the direction of plasticity. The modelling expands quite naturally from the line into the form of the figures. Modelling and line are conceived integrally. Ingres' delicate shading might easily withdraw back to the outline (and ultimately it does) because the fullness of form, exacted by the shading, is implicit in the line. Though the drawing is not "open," the lines are drawn with a lightness and freedom that allow for recession into space. Space, at the same time, is not an absolute quality of the drawing, only insofar as he provides an environment for the figures, a space in which they are free to turn. His line has an assuring control and precision of purpose.

Critics of Ingres accuse him of an intellectual coldness and removal, presumably because his line is not exuberant in execution or obvious in its passion. Such accusations fail to recognize that Ingres' restraint overlays a latent sensuousness which may kindle a more persuasive, almost obsessive expression if we are able to release it. Those who respond only to the temperature of a performance may be deceived by

their bias. For often the heated, emotional gesture proves to be only a vociferous disguise for lack of significant expression.

<center>◇ ◇ ◇</center>

A resolute search for plastic form began in Italy with the intensive interest in the human body during the Renaissance, which is not to suggest plasticity was a quality of all fifteenth- and sixteenth-century Italian draftsmanship; rather, hardly more than a handful were able to realize plastic form to the fullest. Pontormo, Signorelli, and especially Michelangelo are monuments in that handful. Plasticity means more than a rendering technique that imitates volume; it is a term we apply here to a work that apprehends the sculptural reality of a three-dimensional form on a plane surface: it is a conceptual grasp of sculptural fact.

Whatever sense of form we feel in the three preceding drawings is ultimately subordinate to the outline. The hatchings in the *Kneeling Woman* are an addition to the line and Ingres' modelling extends into the figures from the outline. Michelangelo, however, leads our eye directly to the form's interior; the cross-hatching builds *out to* the contour edge. The preoccupation in the *Bathing Soldier* (Figure 15) is at the center; what interest there is at the edge is designed to inform us about the interior, as well as preserve the integrity of the whole. An over-emphasis of outline risks a flattening of dimension. The draftsman who pursues plasticity must begin his drawing from the inside of form— in conception, if not actually with the hand, as did Michelangelo. We can imagine his line responding to the projected image of the figure, probing and cutting the surface as though it were clay, and slowly extricating the form into permanent relief.

In the later Crucifixion series, discussed in Chapter One (Figure 5), Michelangelo's strokes become highly agitated; they search relentlessly, but seem unable to fix the boundary of forms. The groping chalk marks give the drawing a disquieting vibration. Forms appear, by comparison to the present plate, as mass merging outward into the enveloping, energy-charged atmosphere. Space complements form. Yet, as the boundaries of forms begin to dissolve, the concreteness also tends to dissolve into suggestion. The contour edges of the *Bathing Soldier* are more clearly defined. They contain the plastic energy without flattening it.

At the beginning of the sixteenth century Leonardo, Dürer, Raphael, and Grünewald had all created drawings of considerable plasticity, and more followed under the spread of Michelangelo's influence. None,

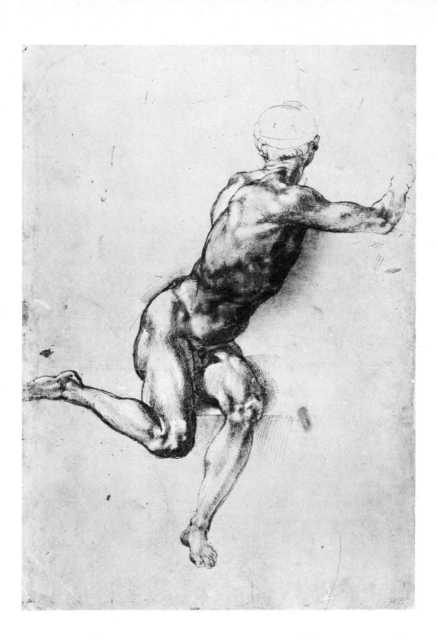

Figure 15
Michelangelo Buonarroti, Italian, 1475-1564.
Bathing Soldier for Cascina cartoon, pen and ink.
British Museum.

however, surpassed his intense understanding of form, which delved far deeper than anatomy. The tension of the bather's complex pose, the sure control of taut transition from one unit of the body to another, the feeling for the human form as a knotted container of energy are all a measure of this depth. Cross-hatching marks out the concrete bulk, loosening it from the flat surface. Line fixes the relationship to space and propels our eye inward and actively into the pose. They are the means of realizing a plastic ideal. Certainly his activity in sculpture did reinforce the drawing; but for the most part we can suspect the communication went the other way. Michelangelo's sense of graphic form is rare for painter or sculptor.

Drawing has a special curiosity about the form of things. We might well consider plastic form as the pivotal point of drawing; a draftsman may move in one direction away from this point toward linear design, or in another toward atmosphere and space, but plastic form remains a core of the drawing organism. Many draftsmen have been intent upon the concreteness of objects, but not necessarily with the spiritual intensity of Michelangelo, nor with the same complex methods. The subjects may be ultra-ordinary or totally abstract; the techniques may revolve around conventionally understood devices or an enigmatic, personal language. And yet the results may be equally plastic.

A less Promethean draftsman than Michelangelo, Jacob de Gheyn reveals in his drawings an inquiring alertness to a breadth of natural form. With the awl of his eye, de Gheyn pierces a microcosm of mice, frogs, moths, caterpillars, and flies, as well as the grander forms of figure and landscape. All of his drawings are studied with an objective warmth. The temperament of *Head of a Young Man* (Figure 16) is quite different from the inflated style of engraving from which de Gheyn's line is derived. Like numerous Dutch and German draftsmen, de Gheyn was influenced by the clarity of linear pattern so necessary to engraving. His line swells and tapers, curves and crosses in the same manner as did the lines incised in copper by engravers of the later sixteenth century. The similarity comes as a natural consequence of an interchange between two areas of his work. A line of swelling and diminishing width is as characteristic of the flexible quill pen as of the burin applied with varying pressure. De Gheyn found the versatile quill even more accommodating to plastic form. The *Head of a Young Man* is drawn as a solid volume by strokes that curve with the contour surface, curling tightly and densely in the mass of hair. His quill line, influenced by the burin, is bolder and more fluid than its engraved equivalent.

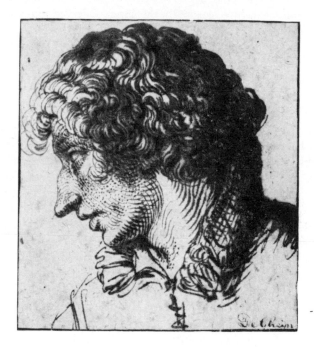

Figure 16
Jacob de Gheyn II, Dutch, 1565-1629.
Head of a Young Man (c.1600-10),
pen and brown ink on brown paper, $3\frac{1}{4} \times 2\frac{7}{8}''$.
Collection of Curtis O. Baer, New York.

In all his drawings, de Gheyn shows a determined concern with the plastic entity. He investigates an object not with an analytic mind, but a curiosity comparable to Pisanello. Like many other "lesser" artists we seldom attend to, de Gheyn has a rightful position at the level of remarkable draftsmanship, especially the kind which inquires deep into natural phenomena.

<div align="center">❖ ❖ ❖</div>

Analysis of form is tangent to plastic drawing. Actually, as soon as an artist begins to interpret the form of an object, his mind has begun to analyze. The analytical process, in many instances, is a mild affair that takes place in the mind alone, leaving slight evidence in the drawing. Umberto Boccioni conducted the process openly and pushed it further toward abstraction. In his drawings, Boccioni was a mixture of analyst, dynamist, and romantic. He was direct and forceful, given to economical graphic statements. As an analytical draftsman Boccioni moved in two directions. Futurism was practically his own private manifesto; during the height of his involvement with the ideas of material entities dissolved in an ambiance of dynamic energy, his drawing concerned itself primarily with analysis of the phenomena of *active* forms. His second direction interests us more. From his earliest work, even among the dynamic motion studies, and after the enthusiasm of futurism had been extinguished by war, Boccioni was strongly inclined analytically to simplify concrete form. He saw volume in terms of planes. The drawing of a male (Figure 17) interprets the figure's torso in just this manner, most clearly at the scapula. Michelangelo's knotty surface becomes a definition of angularity; within the body, line defines the intersection of planes, darker lines emphasize the more important projections, and outline signifies planes turning from our view. The marvelously reductive study of the man's left hand at top of the sheet is indicated with but a few shifting planes. Boccioni analyzes by subtracting the inessential, leaving a diagram which plots only the critical planes and their junctures. The obliqueness of the shoulders is particularly convincing to our eye.

What is tentative planar notation in the male figure becomes in the second drawing (Figure 18) a full commitment to tectonic form. Planes of shallow curve and the lines of their intersection are here the substance of Boccioni's formalism. The drawing examines the sculptural surface of a particular head, not with the same laboratory method one would use to study the skeletal or myological head (Leonardo, for exam-

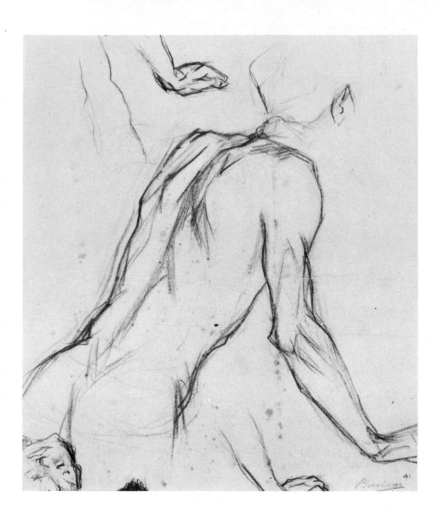

Figure 17
Umberto Boccioni, Italian, 1882-1916.
Studies with Male Nude from the Back (1907),
pencil on ivory paper, $10 \times 8\frac{1}{2}''$.
Courtesy of Mrs. Harry L. Winston.

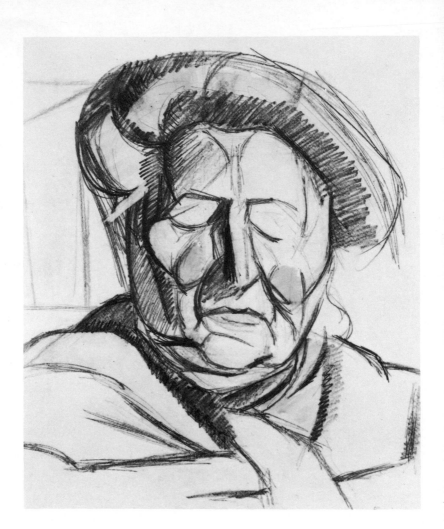

Figure 18
Umberto Boccioni, Italian, 1882-1916.
Portrait of Boccioni's Mother (1915-16), black chalk, red,
green, and blue watercolor on buff paper, $25 \times 20\frac{1}{4}''$.
Courtesy of Mrs. Harry L. Winston.

ple), nor with the method used to arrive at structural and proportional generalizations (Dürer, for example), but to resolve the problems of a particular work. Boccioni analyzes a specific object, drawing out formal structure in order to form a plastic architectural configuration. This is not representation. It is transformation of experienced form into pictorial reality. Cézanne's influence pervades the drawing.

Analysis is a turn of mind away from imitation. As a process of separating the parts from a whole in order to determine their relation to each other and to the whole, analysis must thread through the vision of all good draftsmanship; but by the phrase *analytical drawing* we mean a more thoroughly intent and overt regard for the mechanism of forms. One takes things apart to discover how they work and in order to comprehend them better. Boccioni attained an essential understanding of form by reducing objects to their essential planar order. The process can be more of a virtual dissection as it has been so often with Picasso, Graham Sutherland, or Rico Lebrun. In drawing, the operation is not aseptic surgery performed by the intellect; the intelligence grows within the sentient eye, the rest is groping. Once the artist approaches a felt understanding of form, he will then be equipped to create his own expressive forms—this is true invention.

Portrait of Boccioni's Mother (Figure 18) indicates the beginnings of such a synthesis. The lines which are divisions of the flat surface are also the seams of planes welded into a concrete whole. If we were able to compare the drawing with a sequence of portrait studies of the same subject that began eight years earlier, we would see the process of analytical simplification shearing away surface appearance to gradually uncover the structure of form.

<div align="center">◈ ◈ ◈</div>

Space is the complement of plastic form. In order for a form to appear convincing it must lie within a container of space. As the outline breaks, diminishes, or disappears, the unity with space becomes stronger but plasticity begins to dissipate as a consequence. There are many draftsmen quite willing to sacrifice the plastic entity, anxious to gain a flux of light and mass, the permutable form enveloped in space.

How extraordinary the drawings of Seurat or Cézanne would have appeared to Michelangelo. Surely he would have commented, as he did of Titian, that they were tolerable painters—but such clumsy draftsmen! Their equivocal drawings would be incomprehensibly dull to his firmly sculptural mind. Drawing as a magical art is capable of conjur-

ing numerous identities. One cannot assume a hierarchy in which plastic form is uppermost. Michelangelo's judgment in this case would be formed of bias, as was his appraisal of Titian. Actually, *pictorial* drawings (the term of Charles de Tolnay) become more and more dominant as art progresses from the sixteenth century and painting precipitates into mobile, light-filled space. One "category" of drawing merges with infinite subtlety into another. Therefore it is not possible to give *pictorial* a specific definition, except quite generally, as a conception in which form is either equalled or subordinated to qualities of light, space, and motion. We attach no real significance to the term. It is simply a useful word for suggesting that draftsmen may be committed to interests other than absolute plastic form.

The young lady in Seurat's drawing (Figure 19) is almost indistinguishable from the space in which she is immersed, as though light and air had in one area become dense enough to assume material identity. Other than the implied line of the profile there is only pure chiaroscuro. It represents the method Seurat developed to parallel in drawing his pointillist painting technique. Worked very gently across the paper, the Conté stick leaves small quantities of black crayon on the peaks of the textured surface. Variations in the tonal pattern suggest the broadest modelling of form. The extreme softness of contour fuses the worked area with the untouched surface in a manner that activates the entire drawing. The drawing is almost pure ambiance.

Seurat's paintings indicate that he was deeply concerned with a monumentally stable composition of shapes in space; a composition of extreme solidity and permanence. By comparison with the paintings, his drawings are more transient patterns. Other drawings beside this one possess a greater clarity of outline and come closer to the solidity he anxiously sought in the paintings. In the simplifications of shape, rich patterns of black and white, and soft transitions of tone, Seurat achieves in his drawings a quality of mystery that removes the edge from his "science." He is one of three great poets of Black in the nineteenth century (Redon and Goya are, of course, the others).

As one gives further thought to these few gradations that at first threaten to move by, like shadows cast on blank paper, the lean transparency of tone calls forth a very real and radiating existence not easily removed from the mind. Suggestion is a powerful means of drawing the beholder into a picture. Once we have participated with our own imagination, we become unwilling to withdraw. In contrast to this

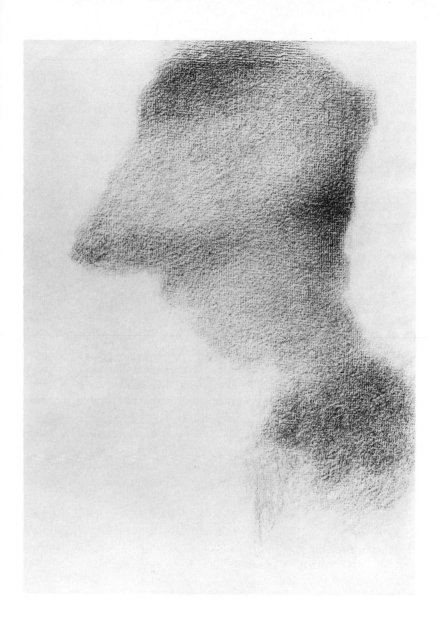

Figure 19
Georges Seurat, French, 1859-1891.
Head of Woman with Hat, Conté crayon.
Smith College Museum of Art.

pulsating softness, Charles Sheeler's *Of Domestic Utility* (Figure 20) is harshly obvious in contour and tonal contrast. The suggestions of academic manner in conventional rendering and virtuosity of execution conceal the abstract formal aims he shares with Seurat. Composition of interlocking shapes, of black and white pattern, and tonic modulation are the compelling qualities of the drawing. It is a deliberate composition of sharp contrasts: sensuousness and precision, angularity and curve, light and shadow. And all of this stands balanced between parochial realism and formal abstraction.

Sheeler spells everything out. The most rigid control and predetermination admit no faltering, no accident. Every shape and tone sits precisely where it must and the focus is sharpened to an extreme. The entire complex is an adventure for the eye to enjoy, but one we finally leave in favor of something less exhausting.

With the blank white paper, the draftsman has before him the imaginary substance of light and space. It is up to him to articulate that material. Tiepolo had a passion for the light-filled surface and he preserved every bit he could. The method of high-keyed chiaroscuro which is his special sign produced an amazing effect of solid, but fluent bodies bathed in luminosity. Behind a drawing such as *Rinaldo and Armida* (Figure 21), disguised by the slight notations of a lambent brush, is a knowledge quite certain about the forms that we see only as mirrors of light. Without a foundation of plastic intelligence these sepia figurations would be hopelessly incoherent.

Cézanne and Tiepolo show an equal awareness of the role played by the surface; in fact, in their two drawings (Figures 21 and 22) the surface plays the major role. Both draftsmen assume the surface to be a volume of light and air that may be differentiated into form and light-space by a minimum of means.

Tiepolo begins his drawing with a light chalk sketch that is a kind of reconnaisance of the idea, approximating the most general disposition. An open and fluid pen line then defines the figural scheme more accurately. The staging is planned. It remains only for the forms to be given substance by articulating the light of the page. A pale sepia wash, laid down in broad strokes, indicates the basic division of light from shadow, followed by the darker nervous brushstrokes that accent the light's pattern and give the drawing its final clarity. We can imagine the whole vigorous procedure beginning and ending with little lapse of time. The marvel of Tiepolo's transmuted surface is possible because

Figure 20
Charles Sheeler, American, 1883 – .
Of Domestic Utility (1933), Conté crayon, 25 × 19⅜″.
Collection, The Museum of Modern Art, New York.
Gift of Abby Aldrich Rockefeller.

a strong conception, and a belief in his own powers of magic, lie behind the drawing.

Cézanne could not tolerate an object-entity in his pictures. For him, objects were significant only in their relation to each other and to the whole. His only concern was the pictorial totality, to apprehend and give to it the greatest solidarity possible. The surface in his work acts as a symbol of unity. He attempts to maintain that unity while revealing at the same time the volumes of his "motif." In his peculiar optics the surface is a field of latent tension. The elements of the picture plane that seek two-dimensional order and the elements of nature's organism —the dynamics of light, form, space—cannot be resolved without considerable stress. *Paysage* (Figure 22) illustrates the abstract language Cézanne developed in his drawing to answer these problems. They consist of the scantest notations: abbreviated lines in pencil or brush, and small patches of watercolor which are important both in tonality and in the warmth or coolness of color. The drawing is almost identical in method to the initial stage of his paintings.

Cézanne defines the volumes of his subject with utmost economy and selection. The "touches" of wash are the basic module in the tectonic pattern of the drawing. He bypasses the inconsequential detail to select the essential junctures of forms and notes them with these patches of transparent color. Every choice is a response of unfaltering perception to relationships emerging in the landscape. A short line divides and directs; an area of wash is a plane angled from the light, indicating an oblique facet of one form and bearing on the contour of its neighbor. Each mark struggles for definition and resolution of the architectural whole. The special skill of Cézanne is his ability to retain a simultaneous balance between picture surface unity and a complex sensation of objective space. He does so by emphasizing in his design the frontal shape pattern (planes that face us) while at the same time giving us the sense of suspending these marks on the surface of volumes which meet and overlap in spatial sequence. The balance of elements is always in maximum tension.

A sensitive understanding of the surface as an active force in drawing obviates the necessity of more elaborate stratagems. As we learn to read Cézanne's cryptic shorthand, his drawing discloses a plastic reality *of the total configuration* more complete, more convincing, than any we have discussed. It would be an advantage to be able to judge the relationships in the transparency of full color; yet, even as it stands in black and white, an airiness and bleaching light suffuse the entire page.

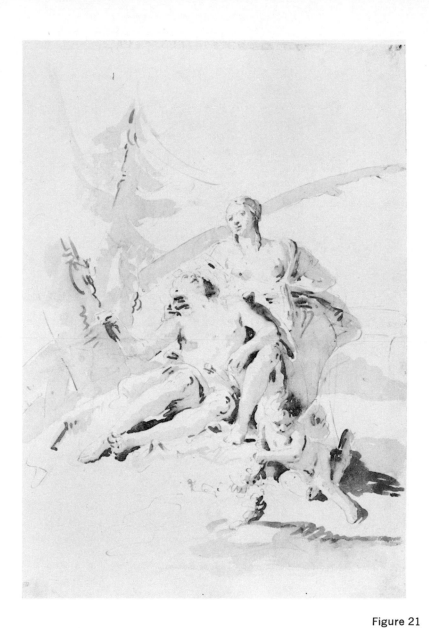

Figure 21
Giovanni Battista Tiepolo, Venetian, 1696-1770.
Rinaldo and Armida, pen and brown (sepia) ink
over black chalk, $16\frac{3}{4} \times 11\frac{3}{8}''$.
Smith College Museum of Art.

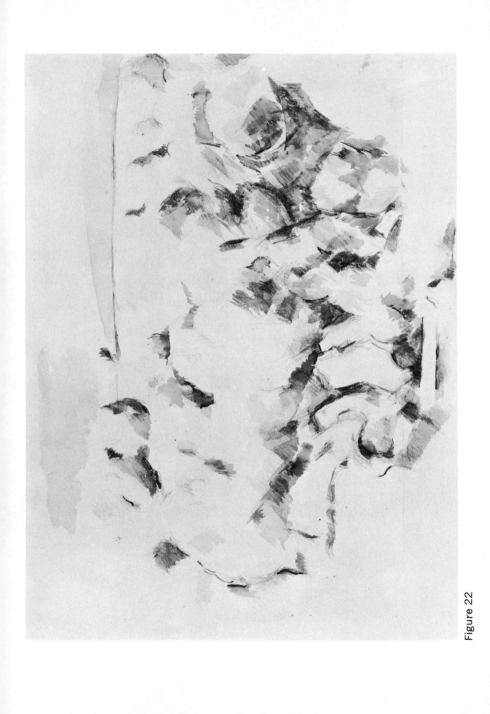

Figure 22

❖ ❖ ❖

Action in drawing may take two forms. The most easily recognized
is a depiction of action—an element in motion, such as the bizarre and
terrific gestures of Henry Fuseli's figures, or the muscular energy in
Tintoretto, or Leonardo's phantasmal studies of hydrokinetics. The
second form is obtained in varying degrees by every drawing: the ac-
tion of drawing itself. Only in the more obviously spirited performance
will the action of drawing give the image a quality of dynamic mobility.

The *Old Man in a Swing* (Figure 23) is caught in the frame of our
vision almost at the head of his pendulous motion. In less than a second
he will disappear in a backward swing, then reappear more gleeful
than before. Because *time* in drawing is reduced to the static surface,
motion will necessarily be arrested. The problem that Goya handles
with such success is to maintain the momentum of an action without
jeopardizing the integral balance of design. A more complex composi-
tion would permit stability through counter-movement; but Goya does
not qualify the action in any way. The old man swings, and swings,
permanently. And everytime we catch him, he is balanced on the
diagonals of the page.

Goya is a master of the portentous moment. So many of his figures
seem to be caught at some tragic, foul, or supercilious act, and they are
drawn with an appropriate economical haste. In the *Old Man on a
Swing,* the execution of line zig-zags in accent of the action; but it is
not the necessary clue. Action of a moving body was Goya's frequent
subject, which he interpreted with the most enormous power of all in
his monumental painting, *The Forge.* Kokoschka's portrait drawing of
Norbert Wien (Figure 24) involves no explicit movement of a figure,
yet he employs the momentum of execution in a way to convince us
of the sitter's immediate presence. Cogent, agitated, and disconcertingly
insistent, the scribbled marks provoke our eye to participate in their
graphic performance. How completely different from the double por-
trait of Ingres. This, however, is not concealment or ruse, camouflage
of vapid expression by dramatic gesture. Kokoschka intensifies ex-
pression. He urges us into the drawing with a rush of chalked strokes;

Figure 22
Paul Cézanne, French, 1839-1906.
Paysage (1895-1900), watercolor and pencil, 13 × 18".
Collection of Frederick B. Deknatel.

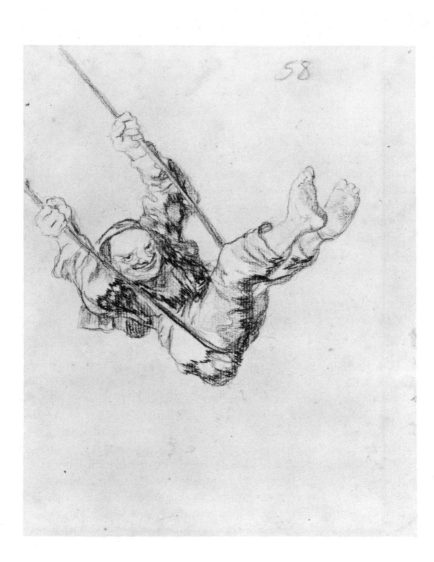

Figure 23
Francisco Goya, Spanish, 1746-1828.
Old Man on a Swing, black chalk.
The Hispanic Society of America.

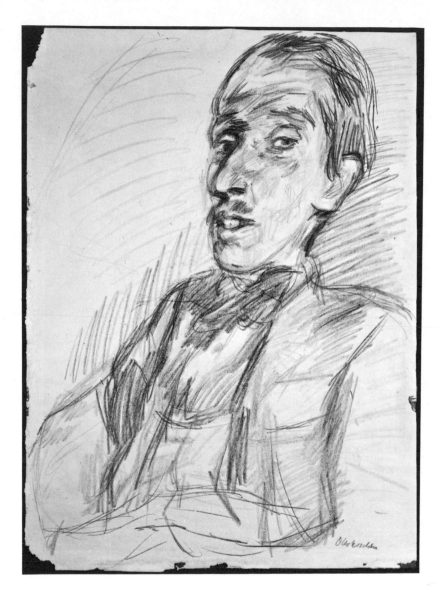

Figure 24
Oscar Kokoschka, Austrian, 1886 — .
Norbert Wein (1920), chalk, $27\frac{9}{16} \times 19\frac{5}{8}''$.
The Dial Collection, on loan at the Worcester Art Museum.

we follow the swiftly executed hatchings as they search the form like the fingers of a blind man. Expression of form, personally felt and urgently probed, is Kokoschka's target. The apparent frenzy of the chalk is controlled to this purpose. Heightened energy of line is here a corollary and expression of exigency—the exigency of an intensified vision.

The axis of Guercino's *Two Figures* (Figure 25) is just to the left of center, down through the forehead, arm, and hip of the young woman. On either side of this axis Guercino balances the weight of his action. As in Kokoschka, the action is in the drawn line. The responsive quill pen possesses the most flexible and versatile personality of any drawing instrument, with the exception of a good brush. Guercino's line, like unravelled thread, undulates with a swiftness typical of a quill. In other drawings, he indulges in the pleasurable virtuosity of pen line for its own sake; but here, there is more restraint. The quill functions in concert with the ink wash to depict a very gentle and genuinely tender expression. Through the energy of cursive movement, Guercino's line infects the forms with its intrinsic vitality. Moreover, it keeps our eye on the move, directing us into-around-across, never once to rest. Because of the protracted movement of our eye in the drawing, we sense animated figures in a fluid space capable of altering their gestures at any moment. The drawing's vibrant fluency is an achievement of the highly active line.

The umber wash stabilizes the linear movement and gives firmness to the figures. Light and air are modulated by the same means. Yet, the tonal design is somehow contradictory to what we would anticipate. Old man-young woman; one expects her youth to be accorded the lambency which Guercino gives to her elder companion, but Guercino's transparent tones are disposed more enigmatically. He balances mystery in her shadowed countenance and fills the void between the two figures with a compelling attraction that haunts the questioning mind.

Guercino was a draftsman of precocious skill. He understood his means; he understood the mechanisms of form, light, and movement. And he used them with an intelligence capable of cogent vision or the

Figure 25
Guercino (Giovanni Francesco Barbieri), Italian, 1591-1660.
Two Figures, pen and wash, $7\frac{3}{8} \times 9\frac{3}{4}''$.
Smith College Museum of Art.

most common errors. His line could be unnecessarily voluble—a deception without substance, a flourish before fact, an egoism. Or when his vision was sharpened to the purpose, Guercino could draw with a precision and economy which approached in power the vital journalism of his contemporary, Rembrandt.

The *graphic mind* assumes many roles, many individual temperaments. Every drawing we have considered proves that; and visual intelligence, if not more definable as a concept, certainly seems more alive through these illustrations. Perhaps the phrase itself—visual intelligence —appears too academic. Granted. However, they are merely convenient words which refer to the understanding and force of mind that gives viable form to drawings such as these.

Figure 26
Edward Hill, American, 1935 —.
Melancholia (1964), lithograph on buff paper, 18″ diameter.

FOUR

Michelangelo's Ark

Jacopo Pontormo valued the paintings of Michelangelo as the greatest achievement of that artist's monumental genius. He felt that Michelangelo, in the frescoed giants of the Sistine Chapel, had achieved his most powerful realization of the human body as expressive form. And since Pontormo considered drawing to be the substance, the foundation of art, we may assume he would agree that in the drawings lies the wellspring of Michelangelo's art. In them Michelangelo is Hercules wrestling with Antaeus. Every drawing is an action determined to grapple, grasp, and subdue the human body, to subdue and constrain its energies long enough to compel them into the order of a plastic image. The body is for him the Great Ark, the container of all emotive experience. Energy, movement, a sequence of muscular forms twisting in space become a sign. The meaning lies in the private Promethean struggle which seized Michelangelo's heart and mind, and which he pursued with deafening intensity equally in all his work. As we have already seen, the drawings reveal this spiritualistic struggle in formation.

Michelangelo is a monolith, the Titan of figure draftsmanship. The effect he had upon subsequent artistic vision of human form is embedded deep in the sixteenth century and has remained vital up to the present. So considerable are the numbers of Master Drawings executed

during the last several hundred years which deal with the nude, the subject deserves consideration by itself—not so much to evaluate its merit, as to reach some understanding of figure drawing as an experience and an expression. And because Michelangelo stands in history as the greatest of figure draftsmen, his plastic vision will shape our point of view.

Pontormo, too, is historically important: his highly individual reaction to Michelangelo's influence; his contribution to a broadening conception of drawing and the beginnings of Mannerism; and his strange inward, sixteenth-century spiritualism. But our history, as such, has been kaleidoscopic, that is, isolating artistic fragments and juxtaposing them freely in time, creating a pattern quite different from the chronology of a true historical view. This oblique approach emphasizes the work above events and gives the whole matter a tone of immediacy. History for the artist means more than a catalogue of significant, interrelated events; it is a storehouse of relevant materials that inform and inspire the present.

The drawings of Pontormo show him to be one of the few masters comparable with Michelangelo. For both these artists, the nude was the real protagonist of their art; it was as though nothing else struck their vision. However, Pontormo as a draftsman is somewhat easier to understand; his line is simpler in method, he reduces the intricate muscle structure, which makes the larger units of the body more apparent and enables us to follow the workings of his eye and hand projecting form onto paper. As we come to recognize the artist's comprehension of the body through the insight of his drawing, we begin also to see the body itself with greater clarity. Although his manner of drawing may be simpler and more accessible to our understanding, Pontormo's perception is no less acute than Michelangelo's. Pontormo explored the optical and psychological aspects of figure drawing with profound fascination. He was alert to every variant of a pose and its implications; but, we find all his study of physical reality, optical effect, and abstract form to be firmly grounded in a comprehensive grasp of the human machine.

What does this mean—a comprehensive grasp of the human machine? Properly, anatomy, that is, the skeletal, muscular, organic, and nervous systems of the body. However, this science does not in itself provide a definition. Art anatomy is more than a category of acquired learning. We may define it as a consciousness of organic geometry, of an underlying logic within the human frame. The artist should develop from

constant perceptive study of the figure, and a full awareness of his own being, a sense of essential bodily construction. He should come to understand the body as a vital architecture, a specifically ordered connection of columns, housings, buttresses, and articulated joints; as an energy plant of elastic muscle, organ, and nerve; as a whole clothed in flesh, and designed in mobile symmetry.

Animated forms instill us with their animation. Daily we are precipitated into life, participating in the dynamic growth and change of our extended radius; and for us, the human body becomes the incarnate symbol of vital form. A figure drawing stands as a direct confrontation of this symbol. Pontormo responded to vital form as few draftsmen have, and drawing solidified his response; drawing gave his experience definition, revealing to him the structural logic of form. Behind all his figural inventions we sense the model closely observed. He is the forebear of Rodin, as well as Signorelli's heir. That is to say, his drawings are at once animate gesture translated to line and physical energy given plastic substance.

Pontormo's drawings give a firm sense of the three-dimensionality of the figure, but this quality hinges upon his feeling for bodily gesture. First his line defines the movement of a particular pose; and then, from the enclosing linear rhythms, a configuration of volumes emerges. The complex attitude of the central figure in Pontormo's first drawing (Figure 27) makes the rhythmic line all the more explicit: from the left hip, the movement of the slender torso curves up to the right shoulder where the weight is buttressed by the upper arm. This catenary suspension, its counterbalance and support, appear to be the focus of the drawing. Gesture is determinate. But it cannot be seen separate from the volume of the body; in fact it leads us to read the forms in spatial sequence. If we enter the drawing through the energetic, moving line, the plastic forms are what finally hold us. The pose itself is derived from Michelangelo; but sensitive observation of the live model has mediated between the inspirational source and the fresh, interpretive drawing, which proves to be the case with so many great draftsmen. Sir Kenneth Clark describes this as "interaction between ideal form remembered and natural appearances observed." *

The attitude of a pose, its complexity or simplicity, its motion or stillness, will largely determine our focus. In the pointing nude, forms are twisted and bent, the axis is torsional; the pose of the second drawing (Figure 28) is extended, the sequence of forms pushing forward on a

* Sir Kenneth Clark, *The Nude*. New York, 1965, p. 218.

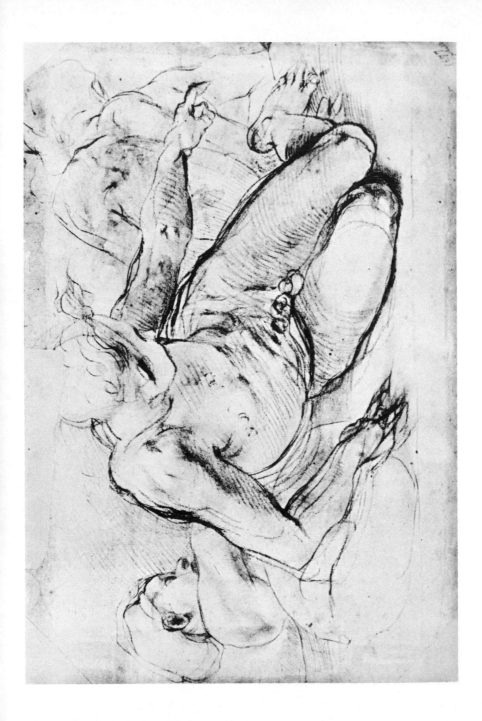

slightly oblique and subtly arched axis. These lateral forms are linked into a whole, a unity which we read more immediately than in the central figure of the previous plate. Both drawings are equal: the same supple line expresses movement, the same sure and forceful drawing suggests volume; each is conceived from a strong sense of living form, never losing sight of three-dimensional fact. What differences exist between them arise from the contrast of attitudes in the figures. The gesture is so convoluted in the pointing youth that we are first aware of complex rhythmic movement in space; whereas, the second drawing is seen readily as a plastic integer, if only because of the simple axis of the procumbent pose.

Before all else the body must be seen *in toto*—a unified sculptural form existing in space—then it may be studied in its sub-units. Some sense of the general character, axial arrangement of parts, tensional balance, and the "feeling" of the pose (from the sensation of projecting oneself into the pose) should precede even the first tentative strokes of a drawing. Two smaller studies in the lower portion of the second plate indicate a simply conceived plan of the figure. Whether they were sketched first as an outline for the more developed study or, as seems more likely, followed as possible variations, these sketches in either case illustrate that a generalized notion of the total figure did underlie the drawing.

The mobile energy of Pontormo's nudes charges the drawings with a vitality of form. Contour outline appears to be his principal means; but as we have seen before, such lines most often give emphasis to the periphery of shape rather than to plastic form. Pontormo apparently contradicts this. There is hardly any concentration on shape outline in these two drawings. Compared with the double portrait by Ingres, a draftsman who uses similar means, a contrast of focus becomes evident. What accounts for the difference? Perhaps nothing more than the inclinations of the draftsmen. Pontormo sees the figure as plastic form; Ingres, as the perfected classical outline. But specifically, in the two Pontormo drawings the line continually directs our eye to follow the roundness of form; it leads our mind into areas beyond view, urging

Figure 27
Jacopo Pontormo, Italian, 1493-1556.
Nude Studies (c.1520), red chalk, $10\frac{3}{4} \times 15\frac{3}{4}''$.
Gabinetto Disegni e Stampe degli Uffizi-Firenze.

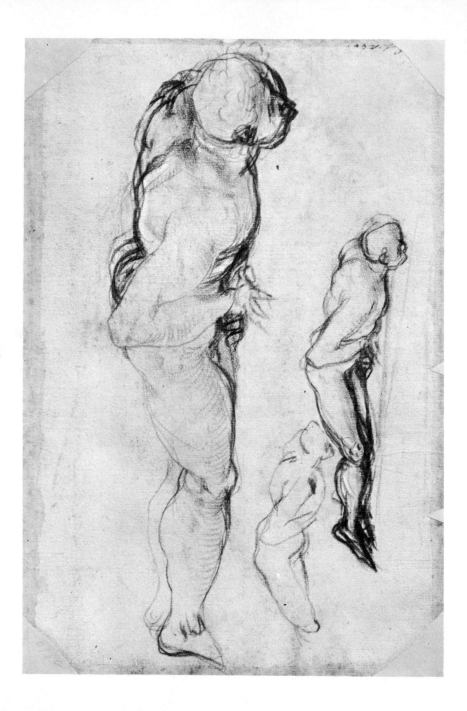

that we sense the entire sculptural body. Every inflection of line counts toward this end.

Vernon Blake has assigned a good deal of significance to this fact as well as to the sense of anatomical construction which is the support of figure drawing:

*"Capable draughtsmen always pay great attention to the direction that the very last fragment of such a contour takes; the line, it is true, leaves off, but the thought of the artist continued to follow the form round into the mass, as did his hand movement when the pencil left the paper; so the mind of the subsequent spectator of the drawing is engaged to follow the same impulse and to feel the real convexity of the muscular— or other—mass that is thus thrown into relief by the very fact of the artist having observed its relief." ***

Notice that Vernon Blake places his emphasis on what the artist observes. How much the statement applies to Pontormo's prone figure— for instance, the line above the calf and its inward projection rounding behind the knee, or the lines of the upper arm merging into shoulder and back; or, in a different manner, the heavier lines of the torso which give that part of the body weight and increase its forward thrust. Further, it is clear how much the hatching functions in accord with the outer line, especially where the contour turns from the edge inward. These two elements serve to render three qualities: the foreshortened circumference of forms, the transition between units of forms, and the sequence of convexity and hollow which is the pattern of muscular form.

The intrepidity of Pontormo's draftsmanship in these two studies amplifies perception, amplifies the sculptural reality of the human body.

<div align="center">❖ ❖ ❖</div>

* Blake, *ibid,* pp. 231-2.

Figure 28
Jacopo Pontormo, Italian, 1493-1556.
Studies for the Israelites Drinking the Water in the Wilderness (c.1525),
black chalk, $10\frac{3}{8} \times 15\frac{5}{8}''$.
Gabinetto Disegni e Stampe degli Uffizi-Firenze.

Vital organic form, opulent flesh, breath, reflex—the reflection of our own anatomy in close reach of our eye—define the nude as a singular drawing experience. The object of all drawing is to intensify experience. However, psychological factors tend to create a hyper-intensity in the encounter of a live model. An indefinable electricity permeates the one-to-one relation, artist to model, and should it cease to exist, or not exist at all, the artist would do as well engaging plaster casts. It is the awesome, almost intimidating reality of a bodily presence which must so greatly affect the figure draftsman.

Excluding the perfunctory performance, figure drawing is a contact with living form which can lead to penetrating study at the most meaningful level. The strength of Pontormo's two drawings alone supports this: figure drawing provides the most fertile experience of form. And the term, form, that we use so much, extends a wide circumference to include many factors. Imagine a nude figure—male, female, it does not matter—and consider that it is a complex organic entity, alive, existing in space, capable of an endless variety of movements and attitudes. Consider that beneath the flesh covering is the mechanism—organ, muscle, bone—which in its function affects the outer surface in myriad ways, both obvious and elusively subtle. The body we now imagine holds within itself the mysteries of energy, articulation, growth, mobility, organic construction and unity: the qualities of living things. From a specific model more specific qualities are drawn. A lithe, mature woman presents a configuration of supple curves, sensuous contrasts which turn the eye through the passage from thorax to waist to a full and sudden thrust of hips and across the shallow rise of her stomach. How surprisingly different are the proportions and shapes from one individual to another; and how endless are the variations from pose to pose, each a new landscape, each a unique problem for the draftsman.

The instruments of drawing are the tools with which to measure these qualities; but, they are not easily apprehended. They can be grasped only through earnest and solemn effort. For Rico Lebrun,

"The live image is a tiger. To rearrange his crossed paws and roll him on his back is more like true drawing than anything I know." *

Lebrun suggests again and again that the draftsman must aggress; only by persistant assault will the "live image" capitulate and give up secrets to an unrelenting line. To other draftsmen the drawing of the nude

* Rico Lebrun, *Drawings*. Berkeley and Los Angeles, 1961, p. 25.

may be at various moments a sober dialogue, a seduction, or a despairing entreaty. Whichever, it must not be a chilly, ritualistic exercise of formula.

In many instances the nude study is intended as a renewal of strength, an act of reassurance through rediscovery. No matter what the motivation or what the drawing aims to probe, it should be a sounding of depths.

<div align="center">◇ ◇ ◇</div>

Each of the three figures in Pontoromo's drawing (Figure 27) show considerable muscular stress. Their actions (which almost suggest three related stages of a figure rising from a prone to an upright position) express a quantity of energy greater than the drawing can resolve; thus the sheet becomes saturated with a compressed tension. What tension that exists in the uneventful repose of Watteau's *Seated Old Man* (Figure 29), while far from negligible, builds at a much slower pace and remains beyond the reach of casual observation. In such a lean frame, bone and muscle are nearly exposed; flesh tightens across the succession of convex and concave form as Watteau marks the conjunction of each unit. The flow and knit of parts, the muscular response throughout the body to even the slightest gesture, seem to be his subject. An outward turning of the left forearm and the thumb barely pressing a sheet of paper effect an arch of the bicep, the right arm lifting away from the torso pulls across the breast; every gesture in this sinewy body produces a consequence elsewhere. The tightly strung anatomy, the flesh covering which contracts about the subcutaneous form create the plastic tension so necessary to quicken the drawing. As he drew, Watteau slowly seized the feeling of volume in each part as well as the subtle muscular strain which relates these parts.

The exquisitely lucid drawing leading across the shoulders and around the base of the neck, the veins and sinews stretching to the jaw, like exposed roots, direct our attention to the head of the old man. Here in the head is the manner of more suggestive and economical drawing we associate with Watteau. It stands out from the rest of the figure which, graphically, seems so atypical. More characteristic are the sheets containing several figure studies in black, red, and white chalk, drawn with an openness and pace appropriate to the momentary subjects. The volumes of these drawings represent the source books of Watteau's paintings and the currency of his reputation. They are visual diaries recording a poetry of "transitoriness" and "melancholy" (two words that

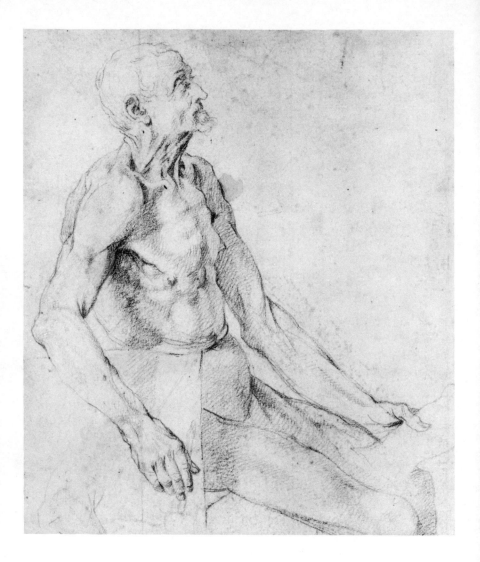

Figure 29
Antoine Watteau, French, 1684-1721.
Old Man (*Seneca*), red chalk, $8\frac{3}{4} \times 7\frac{1}{2}''$.
Courtesy of Mr. and Mrs. Leonard Baskin.

seldom fail to appear in a description of Watteau's art)—the graceful gestures of his elegant contemporaries. These familiar drawings served to fructify the paintings, to stand between experience and expression, and specifically to provide subjects for his great figure-landscape compositions.

But what place does a drawing such as the present one hold? The patient examination and well-controlled means appear similar to his sheets of animals, seashells, and studies after other artists—which this drawing may well be. If so, the first function would be to give him insight into the method of the admired masters' vision (most frequently Rubens). However there is a further, more important insight. Watteau studied with care the interrelatedness of muscular action, cause and effect; but the longer one examines the drawing the more one realizes a subtle dualism of relatedness and opposition between animated form and space. A magnetism, veiled by the soft luminosity of red chalk, energizes the apparent stillness and calm of the drawing. Beneath the arch of the arm and chest, or defined by the forearms, is a space as real, essential, and magnetic as any spatial relation in Watteau's most complex paintings. The importance of the drawing is simply its excellence. But when we see that the fusion between space and form, so carefully observed, parallels the harmony of figure-to-figure, figure-to-landscape space in the paintings, then the drawing becomes assimilated into the stream of the artist's maturing expression.

<div align="center">◇ ◇ ◇</div>

Apart from the human body as an object of study, we must consider also the figure as a vehicle of expression. Of course, these two concepts are not separate compartments of creativity—the latter in one way or another is an imaginative metamorphosis of study experience. Two drawings, the *Bent Figure* (Figure 30) and *Melancholia* (Figure 26, page 73); mark different points in the development of the same expressive theme. The following section presents this writer's brief biography of these two drawings and their *figural idea*.

"The actual origin of the idea is entirely vague. Like so many similar notions, it undoubtedly was born of unconsciously assimilated images drawn from divers sources (in retrospect, the most persistent image is the Adam and Eve of Masaccio's Expulsion). The desire to work with a bending figure became a conscious idea through the inspiration of a Rembrandt seated nude; an altogether different pose which by chance I

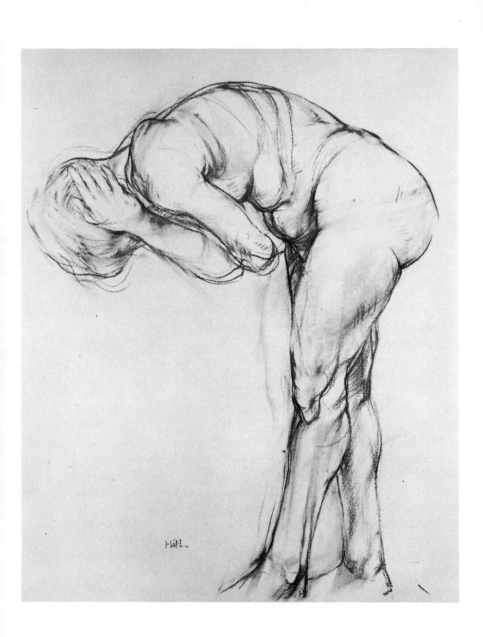

had seen on its side. The incident triggered my imagination. A crowd of images spontaneously fell into place and began to assume a single shape. What followed was a series of five charcoal drawings, a wash drawing and a lithograph all exploring the same idea in various ways.

"The first mental image was put down directly in the vague forms that it came—a woman bent low, legs stiffened and parallel, arms folded into the stomach, head and knees nearly touching, and hair flowing to cover her face. Out on paper the raw, malleable idea, essential and unornamented, could now be developed. I felt at this point the idea should be compared to a live model, not to make a template from reality; rather, to explore all the dimensions of a figure in such a difficult, involuted pose. Three studies were made from the nude, none identical in position or attitude, executed rapidly and without refinement—refinement would only dissipate energy and dilute the idea. Not one of the drawings was less than 14 by 20 inches.

"My object was to find clarity and substance of expression, allowing alternatives to suggest themselves, and changes to evolve naturally. In the initial drawing, the intent to express a bending figure (as opposed to rendering it) resulted in certain inevitable exaggerations of form consonant with the idea of bending. Such distortions are corollaries of expression. The attitude of the model, however, conformed to the intrinsic laws of her body, not my mental image. Her three poses exhibited differences in configuration, which in this instance provoked two appropriate changes.

"With knees straightened, the model could bend forward until the axis of her torso was horizontal—the natural limit for her—whereas, the body was nearly doubled over in my first drawing. The altered position seemed to have greater tension and created, at the same time, an effective monumentality. The second change was spontaneous. As the model became fatigued from the strain of posing, she moved her right arm and clasped the hand around and behind her neck; where it remained, a more fluid gesture, in the subsequent drawings.

"Each of these changes prevailed because they in some way increased the power of the image. Adherence to natural fact was not my concern.

Figure 30
Edward Hill, American, 1935 – .
Bent Figure (1964), charcoal, $33\frac{1}{2} \times 25''$.
Collection of Dr. and Mrs. Malcolm W. Bick.

The drawing should be accurate; but, accuracy, I believe, is really the degree a drawing realizes an artistic intention (expression), not how closely it renders physical appearance.

"The need now was to draw all this experience together and solidify both form and expression. I began two drawings. A circular ink wash study of only the upper portion was started and shortly put aside. The whole figure had to be resolved first. To this purpose, I undertook a large drawing [Figure 30] with charcoal on coarse paper.

"I wanted to draw the figure nearly life size, to form her of a firm, sculptural anatomy that would impose its shape inerasably on the spectator's mind. Through the other drawings both feet had been placed together, the legs parallel and at a slight backward angle to support the cantilevered torso. Somehow this seemed to be an echo of the life-class. As well, it grounded the figure too firmly in time and space. To cut away the life-class connotation and inject a quotient of mystery and mobility, the right leg was redrawn, moving it back to a cross-angle with the other leg. The kind of preternatural expression I sought in this drawing hinges to a considerable extent on an improbable, unexpected ordering of forms. Repositioning the leg not only gave the figure a past and a future, it removed her from the explicable world of practical consequences and suspended her in the space of the mind. At the time it seemed as though this were the last step toward resolution. The strong pivotal hinge of the pelvis and great arch of the spine, the inclined columns of the legs, projecting scapula, and soft, rounded stomach were finally the full contours of an expressive idea.

"However, when I had gained some objective distance, the drawing did not appear nearly so resolved. The metamorphosis was yet incomplete.

"From a large score a composer may take a fragment and develop it into a separate piece, complete in itself, yet not exclusive of the greater whole. Melancholia* came about similarly. The entire group of studies were responsible for the nascence of a thematic idea, an idea which still is to be given maximum form. In Melancholia I drew from all of all of these, but decided to follow the design of the discarded tondo wash drawing. The curvilinear shapes of the upper body well suited the circular frame, and I felt better able to bring solution to this emblematic fragment. Setting the half-figure in the dark, indeterminable

* *Melancholia* was drawn on limestone with a black crayon and then printed in a small edition. It is a lithograph and as such belongs technically to the category of Prints, not Drawings. The relation between these two categories is discussed at the close of Chapter Five.

space brought the body into contrasting relief from the black void. For me, the inward forms when immerged in the deep chiaroscuro became a symbol of the black humour, melancholia. The manner of modelling differs from the other drawings, partly because of the media; but more because the strokes which disclose these sinuous forms are the visible web of a subcutaneous structure of emotional being. This is the expression shaped by the black crayon. Shaped freely from the suggested outline of the six preceding drawings.

"Many ideas which engage an artist's mind become recurrent themes in his work. The bending figure is that sort of image for me."

<center>◇ ◇ ◇</center>

One of the most personal, most refined, and strangely beautiful of all Pontormo's drawings is a sheet with three elongated female youths entitled *Three Graces*. The effect these arcane figures have upon the spectator cannot be easily described or, in fact, comprehended. Two of them gaze out directly at us acknowledging our presence, compelling our attention, drawing us into the seemly, oriental geography of form. Between space and figures there is a deceptive simplicity of relationship that shifts equivocally from the real to the unreal and confounds pragmatic logic. If mystery were a word needing definition, the *Three Graces* would characterize its meaning vivdly. The mystery of fragile line and "dissonant" rhythms is brought to a climax in the central figure.

A separate study for the central Grace (Figure 31) holds a fine balance between lyric outline and subtle descriptive modelling. Beneath the red chalk flesh lies a metamorphic anatomy transformed by Pontormo's profoundly experimental and inventive vision. How different the drawing appears from his previous two. Less bold and energetic in execution, it remains more resolute in expression; less a studied observation, it becomes more a private vision. The two earlier examples of Pontormo concentrate on movement and energy of volumatic form in space, distribution of weight and tension—the vital engineering of the body. The method is immediate, vigorous, and summary. Line searches the contour, making several passes where necessary, and broad hatching enforces the sense of form. The present drawing is concerned with appearances too, but less directly than one would suppose. Appearances here become soluble. They are dissolved and then recast into expressive form by a creative vision which saw each transition, every nuance, every subtle shift of weight and muscular tension as significant beyond the fact of physical anatomy. Pontormo's career was a continuous examina-

tion of human form and a testing of its emotive significance. His attraction to the unusual gesture (especially the figures who pin their gaze upon us, or implicate us with a pointing finger) and to the intorsion of forms is an indication of the psychological and spiritual power the human body held for him.

Shape is dominant in the standing figure (Figure 31—as opposed to volume in Figures 27 and 28). Definition of shape marks the realization of an expressional idea as well as containing the energy of the interior form, not allowing it to diffuse into the surrounding space. The effect is one of a tension and apparent contradiction between the controlling outline and plastic surface as though the body were in half-relief, half freed from the flat page. The line, a perfection of the mind, is at once in union and opposition with the chiaroscuro—the immediate reflection of reality. No eye except the most acute could perceive so accurately the channel of the spine or the modulation of sacrum and buttocks. At the same time, no imagination but the most mature, the most individual, could conceive the expressive unity of two ideals (plastic and linear) as they are here. When this figure is transposed to the complete composition, the only pertinent alteration is a reduction of modelling, in quantity and contrast. The plasticity then diminishes—to the edge of form—and the drawing is removed further from the real to the imaginary. But always in Pontormo we find the real and the abstract, the logical and the irrational inextricably intertwined. The *Three Graces* receives its strange balance from an intensely private spirit and original sensibility. Pontormo appropriated the human form through drawing; that is, he came to know it so thoroughly that he could deny its objective reality, turning the bodily forms into a map of his own mind.

<div align="center">◇ ◇ ◇</div>

Why should we reserve so much space for one category of the larger subject—why the figure?

The nude is the best school of study, to paraphrase Vernon Blake and numerous writers and masters who have echoed these words until they ring like the dusty proclamation of some nineteenth-century pedant. During the last hundred years there has been an increasing tendency to recoil from such advice, or at least to question it strongly. Ambivalence has replaced enthusiasm. The cause—the redoubtable creation of classicism and art academies—the academic nude. We need say little of her (or him), only that this opponent of vital art has instilled many artists with a not-unjustified suspicion of the nude as a foundation of

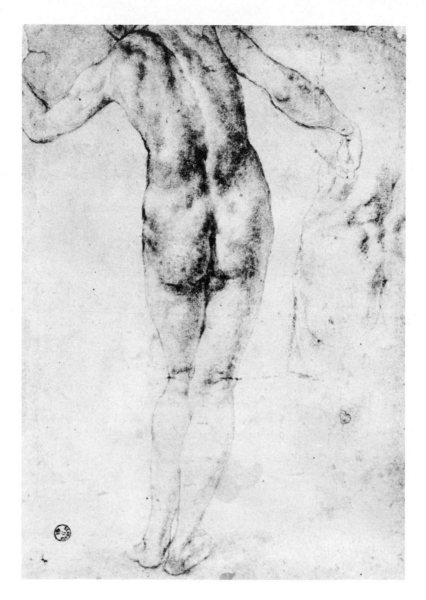

Figure 31
Jacopo Pontormo, Italian, 1493-1556.
Studies for the Three Graces (c.1535),
red chalk, $11\frac{1}{2} \times 8\frac{1}{8}''$.
Gabinetto Disegni e Stampe degli Uffizi-Firenze.

learning. The image we have formed of the academic life-class is all gray: model and students almost indistinguishable from the plaster casts which surround them; the model frozen in some patent pose—the students working slower than the clock; their professor droning an incantation to the Greeks, reciting the rules of perfected form like a daily prayer; and the air a thick fog of charcoal dust. The image is over-stated. Perhaps a hundred or so years hence our present academies and their cluttered, colorful, experimental design classes filled with the excitement of "creative discovery" will be equally exaggerated by those who are reacting against them. Nonetheless, it is true that these life-classes were largely "life"-less, sterile, uninspired, and saturated with conventions. *The nude is a school of profound drawing experience* remains a truth. The conditions under which this remains true, however, must be other than what was standard in the nineteenth-century life-class.

The figure, above all, is a vital organism, and must be experienced as such. Rodin's solution was to fill his studio and yard with nude models who moved at will, following their instincts while Rodin drew them with appropriate brevity and fluidness. Drawings by Pontormo show that his eye was constantly alert to the activities and casual poses of his apprentices. Degas drew in the ballet studio, Reginald Marsh on the beaches of New York, and Lautrec in brothels. The figure-conscious draftsman absorbs the human form around him as a continual occupation. Whatever the specific conditions or procedure (the traditional pattern is basically workable), the temper of the situation must be alive—this is the responsibility of everyone involved:

"It is to life we must recur—to warm, fleshy, genial life—for animated forms." *

Fuseli's remark deserves underlining. Viable forms exist in our art only if we have first experienced them in "warm, fleshy, genial life."

The nude is a principal school of form. An overwhelming multiplicity of forms encompass us and all have bearing on the creative mind. Can we justifiably single out the human body as a first school? Yes, for two reasons: the working principles of construction, articulation, proportion, diversity, and unity which drawing can disclose in the nude, as we have seen in these limited examples, are an analogue of essential form, a key to understanding all form; and the second reason, the human body is the physical center of our world.

* Quoted in Eudo Mason, *The Mind of Henry Fuseli*. London, 1951, p. 310.

FIVE

Materials and Miscellanea: A Philosophy of Craft

The craft of drawing is the least complex of any art. Nothing comparable to the technical problems of the chemistry or "secret formulae" in painting, the structural stress of architectural materials, grounds and mordants in etching, or methods of casting, trouble the draftsman. No art discipline could be much simpler in science than pen, pencil, etc., and paper.

In painting, the professional student is wise to acquaint himself with paint science, that is, the composition and characteristics of the materials. The reason is practical. A painting represents a fragile surface of pigments of various chemical origins suspended in an aqueous, unctuous, or synthetic resin binder, adhering to a plane support. The intricate balance of these interacting substances will determine the state of health or permanency of the paint surface. With poor science, cracking, yellowing, bleeding, deterioration of ground can seriously alter the painting image and thereby the artistic intention. So delicate is this chemistry, that even when put together with the soundest procedures, a painting will alter its face as time works at the surface and the molecular mutation continues beneath. The object of craft knowledge is to reduce the margin of change, certainly to a point short of deterioration of the image.

To the draftsman these technical problems are far less notable. Still a drawing is quite frail. It may be easily torn, crumpled, stained, smudged, watersoaked; but reasonable protection should insure its safety. There are, besides these, the alteration of ink or paper coloration (they are especially sensitive to sunlight) and the effect which some strong media may have on paper. The composition of paper is probably the most serious problem of permanence for the draftsman. We have all experienced how quickly a newspaper begins to look like the tarnished souvenir of a past era. Wood pulp composition, newsprint, for example, and bleaching additives will cause paper to yellow and eventually to deteriorate. Once the draftsman is aware of this and the unsuitable characteristics of other materials, he either avoids them or is careful where they are used.

Familiarity with craft science is not the same critical concern for the draftsman as it is for the painter. For one thing, many drawings are made with no intention other than to plan, visualize, or sketch an idea designed for permanent form elsewhere. In this case the later fate of the drawing may not be of particular consequence to the artist. However, it is good studio practice to have regard for a measure of permanency in all procedures. There is a more basic reason why knowledge of materials is important. If a draftsman can gain insight by examining the properties of his materials' composition, he presumably will be better equipped to make full and natural use of them. To accomplish this examination there is no need for the studio to be transformed into a laboratory; excellent technical literature will provide the artist with abundant information on the history, chemical composition, and characteristics of art materials and the various basic procedures. The most definitive accounting of the drawing craft available in English* is the sound study written by James Watrous, *The Craft of Old-Master Drawings*. Watrous' volume is oriented both to the studio and to the historian and is supported by his own testing of materials and earlier literature, in correlation with a close examination of master drawings. In the foreword Watrous states, "the exploration of modern materials and the re-evaluation of techniques of earlier masters by contemporary artists are stimulated by the desire to discover the technical resources, whatever they may be, which will most effectively assist them in at-

* The most thorough technical study of drawing is *Die Handzeichung: Ihr Technik und Entwicklung* [The Technique and Development of Drawing] by Joseph Meder. It surveys not only the materials, but method of perspective, figural and compositional design, etc., as evidenced in master drawings. 2nd ed., Vienna, 1923.

taining their goals of personal artistic expression." * He proceeds then to an accounting of the established drawing media, ending each chapter with a description of workshop procedures. The specific materials Watrous examines are those which comprise the largest body of master-work: metalpoint; quill, reed, and steel pen; natural and fabricated chalk; crayon, graphite, and charcoal; carbon, iron-gall, bistre and sepia ink; and, in an entire chapter, chiaroscuro drawing, which is a category of combined materials used in a particular manner.

Only slight mention of the brush is made in Watrous' text, and then as accomplice to pen or metalpoint. By itself, the brush has proven to possess the most infectious, most responsive personality, and widest vocabulary of any graphic instrument. The drawings of Goya alone corroborate this; yet, seldom is it discussed in a graphic context. For that reason we single out the brush here. Of course *brush* is a genus with many specific kinds under its heading; characteristics vary with each, and each has its specific utility for the draftsman. The oriental brush previously discussed (Figures 1 and 2, pages 3 and 4), the broad flat brush responsible for the monumental linear structure in the painting by Franz Kline (See figure 42, page 134), the long-handled bristle brush used throughout the landscape study *New Hampshire* (Figure 32), and the soft, round brush of Goya's drawing, are all individual types, each with its own subtly distinctive personality. Such diversity of line and quality of tone are difficult to conceive in any other medium.

The sunlit drawing, Goya's *Pesadilla* (Figure 33)—a coruscation that exposes like a photoflash the dark madness of this juggled as-semblage—clearly reveals also the very personal relation between artist—materials—vision. Vibrant and fluid, the brush's nature perfectly suited Goya. It was the embodiment of his visions. Exactly what kind of brush he used is difficult to determine, and it may well be that in many drawings he employed both fine and broad brushes; but in the present drawing he had undoubtedly used only one and it is quite similar to the oriental writing brush. In both *Pesadilla* and *New Hamp-shire* the artists employed a medium which at times was diluted in order to increase the tonal range of the drawings. Both artists have used the brush in a variety of ways; at the tip, on its side, with heavy pressure, lightly passing it across the surface, twisting and pushing, and so on— all the acrobatics of which the brush is capable have been put to pur-pose. Spontaneity and freshness are valued qualities in drawing. Essen-

* James Watrous, *The Craft of Old-Master Drawings.* Madison, Wisconsin, 1957, p. vii.

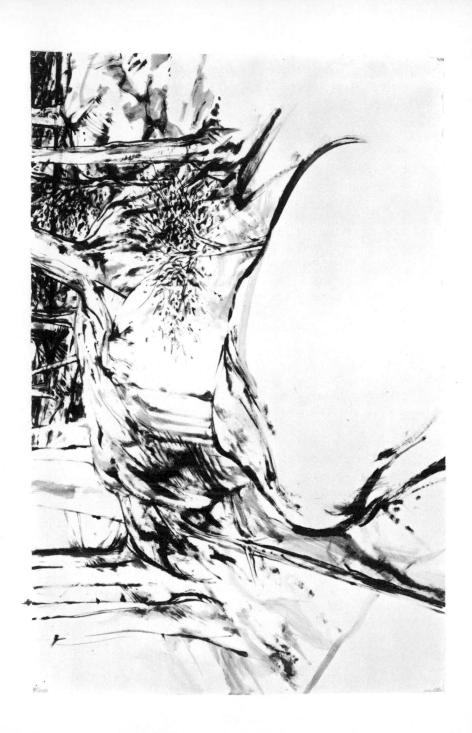

tially these lie in the draftsman's conception and performance; it seems, however, that the brush has a propensity for spontaneity and therefore will frequently encourage a draftsman toward a freer, more direct response to drawing.

An understanding of materials should be the draftsman's companion. A text such as Watrous' will supply a great quantity of information, but it cannot substitute for direct experience with the materials. Craft knowledge can be knowledge of a dangerous sort, a cover-up, a dodge from the expressional commitments of art-making. One can so easily hide behind the beautifully executed pen or silverpoint line; at the same time technical ignorance has no virtue. (In one way the simplicity of the drawing craft minimizes this problem because the elegant line is a disguise more readily exposed than a golden glaze of oil paint.) The draftsman should explore the inherent personality of the various drawing media in search of those materials most sympathetic to the "goals of personal artistic expression," but should not allow the exploration to become a diversion. We know that each tool, each medium, has its own voice. Assessment of the material means should come from direct contact with them, using a particular medium in connection with visual problems and seeing where it leads. The materials themselves will have a disposition or inclination—we must find our own relation to that natural proclivity. Sharpened graphite led Ingres to the edge of form; the lithographic crayon led Redon to dark images. Of course, they were inclined that way; the medium pushed them further toward realization. There are only rare instances of a draftsman working solely with one medium. Ingres used crayon and pen as well, and Redon was equally a master of charcoal, Conté, and pastel. Other materials may extend or vary the range of expression. They may also keep the artist on his toes, avoidng a habitual working pattern. The capricious personality of Picasso operates at many levels with an astonishingly varied range of media. But one should not aim either to perfect one vehicle or to deliberately achieve "multilingual" mastery. Drawing at best is not showmanship; so we let the materials fall where they may.

The solution to artistic problems is not *in* the perfect instrument, the

Figure 32
Edward Hill, American, 1935 – .
New Hampshire (1965),
brush and umber polymer-acrylic wash, $25\frac{1}{2} \times 39\frac{3}{4}''$.

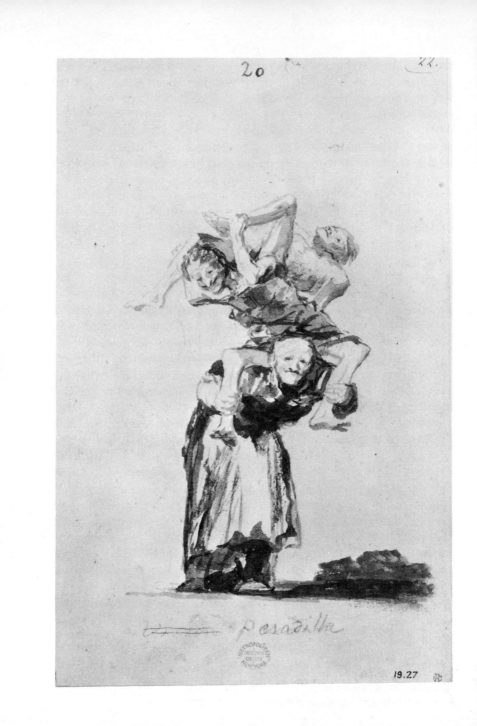

Pesadilla

perfect technique, although artists often act under the general hope of a material panacea. A draftsman's "problems" lie in his vision, his conception, and find resolution between his eye and the drawing surface. Nevertheless there is some validity in such desperate faith. In the way that drawing is a learning about oneself, the personality of a medium or tool may lead to a surer insight of one's own personality. So that the draftsman who struggles unavailingly to render his vision in fine pen hatching may discover, through a chance alternative, that he is able to outline his vision with pencil or brush. The drawing materials viewed broadly are coequal; no one is preferential or comes with fuller guarantees; and we should assess them openly, without prejudice. But in personal experience we find them disparate. The variables of artistic personality account for the fact that some materials seem stubborn and others accommodating. Unfortunately, the only road for the draftsman to follow is that of unending trial and frequent error. There are private histories that tell, for example, of an artist who scrupulously pursues an expression in painting to discover toward the end of his career that his passion for form would find fuller realization in sculpture. The materials of craft do play their very important role. They are the physical vehicle of expression and artistry; without a fusion between these the most fluent materials will say nothing or, at best, say it poorly.

A material's personality, the limitations of media—what are these? We can determine much from examining master drawings, studying reproductions, and reading; and the sum of this experience should prove only that a given medium apparently possesses as many personalities as artists who employ it. This may be an exaggeration, but so is the idea that the nature and use of a medium can be classified. In part they can; however, ultimately each artist must be given the task of defining materials for himself through working with them. Conventions and technique formulae should be avoided except as one may find a natural sympathy with them, and then they are no more than a general guide, a pattern to be modified by daily performance.

"Truth to material," that abused and tattered aphorism, proves to be

Figure 33
Francisco Goya, Spanish, 1746-1828.
Pesadilla (1814-19), brush and ink wash, $9\frac{3}{16} \times 5\frac{11}{16}''$.
The Metropolitan Museum of Art, Rogers Fund, 1919.

as much a question of whether the materials are true to the "idea." We accept the notion that an artist should use his chosen materials in a way that is a correlation of the materials' personality and his own; but standards for materials cannot be specified. The artist must use them in the manner that feels most natural to him and hope for the best. The responsiveness must be mutual; thus truth to material is a private agreement.

There are no limitations regarding the kind of materials that may be used in drawing, no regulations concerning their use or combination. The most unorthodox material means may shape a graphic statement as valid, as powerful as those created from the accepted repertory. To realize the form of a specific idea, it may be indeed necessary to contrive original or unusual means. The process can work the other way as well. New materials will often pique imagination to fresh invention and stimulate perception. Always, however, there is the danger of method and materials becoming a rather comfortable preoccupation, of unusual media being a substitute for original vision; to use the familiar phrase—of means becoming the end.

<div style="text-align:center">◇ ◇ ◇</div>

Mixed media are not uncommon in drawing. An artist combines media when he feels a coalition is necessary to extend the means far enough to realize his intention. Most often this develops from an interchange of ideas and technique between areas of his work—of printmaking, sculpture, painting, for instance. The historical point of departure is undoubtedly the *chiaroscuro drawing,* which was derived from the traditional method of underpainting. It may be defined as a drawing which employs a toned ground approximately equal to a middle gray, the forms then drawn in both light and dark media, such as the head study by Eustache Le Sueur (see Figure 52, p. 146), where he has used white and black chalk on a deep tan paper.

Adam and Eve by Rico Lebrun (Figure 47, p. 141), like others of his drawings, is the progeny of this tradition, particularly as given to us by German masters such as Hans Baldung Grien or Altdorfer. An equally robust draftsman, Lebrun frequently combined ink and wax (and in this instance, casein) in order to achieve the appearance of sculptural forms immersed in a tenebrous space. These drawings generally were begun with pen or brush and a light ink line used to explore the compositional idea, followed by a second stage in which he applied clear

wax to the forward mass of the figures and laid over the whole sheet a succession of ink washes which the wax would largely resist. In the present drawing, the opaque casein was probably used between these stages. At times Lebrun would scratch back through the layers of ink and wax, so that he was able, with his involved method of multiple media, to evolve a complex form defined by complex means. The drawing shows clearly that Lebrun's trenchant sensibilities insistently bound his elaborate technique to his powerful, muscular imagery. And on this fact rests the justification of such technique. With a lesser vision, the mixed method would be little more than creative entertainment.

<div align="center">◇ ◇ ◇</div>

At the base end of drawing is the pure graphic concept of line, which becomes compounded by additional qualities as drawing moves away from the conceptual base. Most drawings are not pure line. They elaborate the linear means in various ways, much as we have seen. Color stands opposite line. It is the fundamental pictorial means of painting; yet, so many drawings do utilize color that one may wonder at what point a drawing is no longer a drawing. We might well leave this conundrum to the theoretician or semanticist; however, it can serve to make a distinction pertinent to our whole approach. In regard to color, we can attempt to answer the question by placing it as we have opposite line, like red and green. If red and green (chromatic opposites) are intermixed one qualifies the other until they reach a balance point at which neither has any dominance. There is no fast division between them, only the neutral center which cannot be characterized as reddish or greenish. So it is with line and color, or rather with the conceptions they represent, drawing and painting. At diametrical points there exist what might be considered the pure concepts, but the broadest area consists of an interchange between these two. It would be possible to say that a drawing which relies heavily upon color for its effect lies too far from the base point to any longer be described as a drawing. Why would we call this imaginary work a drawing at all? Most likely because it was executed in materials traditionally associated with drawing (for instance, pen, paper, and washes). We arrive at a distinction: either a material or a conceptual definition may be applied, and in certain works the two may be disparate. That is, a design shaped by a brush in oil on canvas could well be created by a thoroughly graphic, draftsmanly vision and therefore would be described conceptually as a

drawing. Ultimately the apposite fact is the power or quality of the image, not this question of nomenclature. However, it is important to recognize the distinction between a material and a conceptual definition which often are confused in discussion. A classification of a work of art based upon the materials used is simply a convenience, albeit the most usual method of definition. A conceptual definition, far more difficult to arrive at, remains the only really meaningful approach.

<p style="text-align:center">◇ ◇ ◇</p>

The various methods of printmaking—etching, engraving, lithography, woodcut, and so forth—are categories of the graphic arts and commonly are allied with drawing. Aside from the fact of a multiply-produced image, the distinguishing factors of printmaking are the materials and technical methods. It is therefore possible for these techniques to accommodate either drawing, painting, or sculptural concepts. For almost entirely practical reasons the first association has always been with drawing. The limitations of intaglio and relief printing at their beginning in the fifteenth century made color and soft transitions of tone nearly unthinkable. Line was the practical means. In time, with inventions of new techniques and the development of superb skills, the qualities of painting could be nearly matched in printmaking. However, the initial association remained.

A great percentage of creative prints are a correlation of drawing conceptions, but the complexities and characteristics of media elicit a change in response which tend toward a modification and extension of the draftsman's vision. Two media, engraving and drypoint, are especially close to drawing. Let us take one example: the drypoint by Lovis Corinth is a particularly good illustration because it brings out again the often equivocal relation between painting and drawing.

Drypoint is a deceptively simple technique in which a hard, pointed instrument incises the design into a metal plate. The cut itself and the burr pushed up on either side of the line carry the ink that is transferred to paper in the printing. A sharp tool drawn firmly across a metal surface, the pressure of the hand and resistance of metal give a dis-

Figure 34
Lovis Corinth, German, 1858-1925.
Pieta (1920), drypoint, $10 \times 12\frac{1}{2}''$.
Collection of the author.

tinctive feel and character to this medium and in turn to the image. Rembrandt employed drypoint extensively in combination with etched line; on occasion he used it alone, as have Munch, Ensor, and Picasso, creating masterworks of this medium. Few artists, however, have used dry point as prodigiously as Lovis Corinth; of some nine hundred recorded prints he produced, the bulk are drypoint. The *Pieta* (Figure 34) typifies the qualities of drypoint, and gives reason to consider Corinth the great master of this most direct of all intaglio techniques.

Corinth's composition is based upon a large painting (1889) from the first decade of his career, although the print was executed thirty-one years later, in 1920. This long separation in time brought to the image a metamorphosis of his expressive vision. In contrast to the drypoint, his early painting is extremely graphic and explicit in its description of the figures, accessories, and setting; the chiaroscuro is carefully observed and clearly articulated; the mood stands as dramatic pathos, but controlled and restrained. Especially after 1910, Corinth's work became more overt in its passion, more subjective, and impressed with the changing temperament of the early twentieth century; his paintings became far more direct, compulsive, painterly. All of this was applied to his prints as well. The transformation of expression is manifested equally in his brushstroke or incised line. These marks take on an energy and meaning of their own, almost explosive in activity; they seem to actually overtake the objective forms. Corinth's drypoint is far less defined in its light and form, considerably more ambiguous than the sharply focused painting. The anatomy of Christ, so precise in the painting, can only be read in the print as the anatomy of an expressive statement energized by the hand that forced these hatchings into the metal. Like Van Gogh, like Rembrandt and others, Corinth is in nature as much a draftsman as a painter. His vision, which sees a mutable mass through shifting tonalities, which sacrifices contained plasticity and descriptive form, is that of a painter; the hand that charges these ambiguous forms and gives them what edge they have, that feels the strength and purpose of the incised marks, belongs to a draftsman. This is not a dichotomy but a coalescence.

Corinth's understanding of his material means and his awareness of the character of drypoint line become intrinsic qualities of the final image, so intertwined with the process of seeing and forming that factors of materials and technique only enter our consciousness secondarily, if at all.

In a way our attitude toward craft is ambivalent. To make too much

of it can mislead, but to disregard craft is a mistake. The materials are, after all, the physical frame of artistic ideas. It is perhaps this: the draftsman should understand his craft, attune himself to the nature of his material means, but not become preoccupied or diverted by them. A sensitivity for materials burnishes expression.

Figure 35
Cesare Pollini (?), Italian, c.1560-c.1630.
Renaissance Studio, pen and wash, $4 \times 8\frac{3}{8}''$.
Museum of Art, Rhode Island School of Design.
Providence, Rhode Island.

SIX

The Pedagogical Mirror

Master and pupil: the relation between these two has become legend. Whether in the academy or the studio apprenticeship, drawing has been traditionally the first area of encounter. "Submit yourself to the direction of a master as early as possible, and do not leave him until you must. . . . As has been said, you begin with drawing." (Cennini.) The pattern has changed somewhat in contemporary teaching where design frequently shares this position and occasionally pre-empts it. In the past there was not the division of disciplines now found in art school catalogs; then, the term drawing represented a broader study. Despite changing attitudes toward program content and modes of instruction, the educational experience rests finally in the contact of two personalities, one seeking and the other directing, guiding. This is the significant variable no syllabus or theoretical treatise can account for, except in the most general fashion. There can be no doubt, however, that methods of teaching, the ideas presented, and the nature of the problems are important. In fact, these are what we shall consider.

How can one be taught to draw? The answer is that, other than learning a conventional method of graphic representation, one cannot. If a fertile understanding is our goal and individual artistic vision our precious concern, then a student can only be taught to see. Perhaps not

even that; it may be that an instructor can only provide experiences which may bring a student to insights, and share with the young artist his own mature vision. Yet the precept behind much of the history of instruction is that one can be taught to draw, and often in the belief that a genuine artistic vision can develop on a conventionalized base. In many instances it does, if only because artistic genius seems to have the stuff to survive even the most mediocre conditions.

The first stage of instruction in the Renaissance studio was to set the apprentice working from master drawings, and later from paintings (largely for composition) and antique sultpure, as we see depicted in Cesare Pollini's drawing (Figure 35). Although modified considerably, this practice was inherited from the medieval workshops. No method other than copying had been employed by the earlier artists, their models taken from patternbooks of nearly uniform content. In the last decade of the fourteenth century Cennino Cennini, quoted above, advised with characteristic poetry:

"Take pains and pleasure in constantly copying the best things you can find done by the hand of great masters. . . . If you follow the course of one man through constant practice, your intelligence would have to be crude indeed for you not to get some nourishment from it. Then you will find, if nature has granted you any imagination at all, that you will eventually acquire a style individual to yourself, and it cannot help being good; because your hand and your mind, being always accustomed to gather flowers, will ill know how to pluck thorns." *

Drawing from masterworks remained basic instruction until the latter half of the nineteenth century, although presented under varying philosophies and fortified by other methods of learning. These other methods were variously related to nature as the companion source of study. It has been fundamental to the character of modern drawing (that is, since the Renaissance) that it represents a means of confronting the real world. Even Cennini in his own pre-modern way felt the cogency of nature as an instrument of learning.

"Mind you, the most perfect steersman that you can have, and the best helm, lie in the triumphal gateway of copying from nature. And this outdoes all other models; and always rely on this with a stout heart, especially as you begin to gain some judgment in draftsmanship. Do not

* Cennino d'Andrea Cennini, *The Craftsman's Handbook,* trans. Daniel V. Thompson, Jr. New Haven, 1933, chapter XXVII.

*fail, as you go on, to draw something every day, for no matter how little it is, it will be well worth while, and will do you a world of good." **

True, he had in mind something other than what such advice means today; but in any case he presents us with the principal sources of instruction—nature and art itself. In considering these two, it is necessary to separate the last hundred years from the previous four centuries, for two important notions that hold more or less firmly until midway in the nineteenth century have been subject to challenge and abandonment since then. The notions are these: the primary tasks of art are, first, to meet and in some way represent nature; and second, to perfect or idealize through artistic judgment the forms found in nature. We do not intend that this applies uniformly to all art and artists between 1450 and 1850. They are the general ideas which will help us to understand traditional pedagogy; and once understanding it, we will be able to relate this tradition to the present.

Copying from master drawings, copybooks, and so on, may be seen to function toward two, perhaps three, ends. For one, it brought the young artist directly to the lessons of great art—in classical terms, to the precepts and canons of ideal form. It gave the classical student the model by which he would perfect the forms of nature. A second function of this training, more basic to the whole issue, was that it provided the student with accepted modes of representation—a graphic vocabulary to prepare him to confront and interpret the crowding experiences of the real world. In the terms of E. H. Gombrich, it provided the schema which the artist needs to structure and to form natural experience. Both of these functions rub our contemporary sensibilities the wrong way. Today we are willing to recognize the validity of "copying" only as an intimate dialogue in which the student questions a master in order to uncover the workings of his art, or to work variations in search of insights, and to draw sustenance. Perhaps there is enough of a distinction to separate this as a third function.

It is important for us to realize that such didactic practice, whatever its explicit intention, can in fact have results all the way from enervating to energizing. A slavish, thoughtless copy has few rewards; whereas a sensitive inquiry may bring through interpretation significant understanding. The ultimate value corresponds to the attitude and intelligence with which an artist undertakes this kind of study. Many mature artists periodically return to a direct study of a master's work; and possessing

* Cennini, chapter XXVIII.

a more developed vision, they are better equipped to gain from the experience.

The numbers of copy-drawings extant are overwhelming. Among them are quite a few of considerable inherent value, which illuminate the bearing such drawings have upon the creative mind, the range of personal interpretation and transformation, the pragmatic functions, and finally the extent to which art is a source of art. Rubens, for one example (as shown in a set of articles by Michael Jaffé),* a collector of judgment and fortune, was also a purposeful acquirer of drawings, putting them directly to the use of his studio. Not only did Rubens make numerous copies after great and small masters, he repaired, enhanced, and altered the drawings he acquired to prepare them for his pupils' study, as well as to increase his own vocabulary of form and design. These drawings, both the complete copies and those he reworked, reveal the remarkable extent to which Rubens could adapt himself to the temperament of another artist, adopt and transform this experience into his own creative work.

In the chapter "Formula and Experience" in Gombrich's well-known study, *Art and Illusion,* the author presents the need for schemata: it is easier, he says, to learn to represent form from art than from nature. Certainly if one will settle for a rote knowledge, this provides the surest means; but Gombrich insists that the artist requires some schema in order to orient himself to forming and structuring his perception on paper or canvas. It is difficult to disagree. If we could accept that there exist canons of form, could hold to the notion of nature as a "collective idea" (Henry Fuseli), and/or could believe representation to be the task of art, then it would not be hard to understand the usefulness of such models as the drawings of Raphael or the didactic plates from José de Ribera's copybook (Figure 36). They would fit easily into our pattern of creative development. For we would find in drawing from them the sure form of geometric perfection, the schema with which to unravel experience, and the modes to represent the forms our prepared eye apprehended from nature. But, of course, these ideals no longer hold true for our time. Gombrich is aware of this and expresses the importance of a schema in more contemporary terms: "It is the starting point for corrections, adjustments, adaptions, the means to probe reality and wrestle with the particular." He sees it clearly as a tool to be used intelligently and tempered by a willingness, "to learn, to make and match

* Michael Jaffé, "Rubens as a Collector of Drawings," *Master Drawings,* Vol. II/No. 4 and Vol. III/No. 1. New York, 1965.

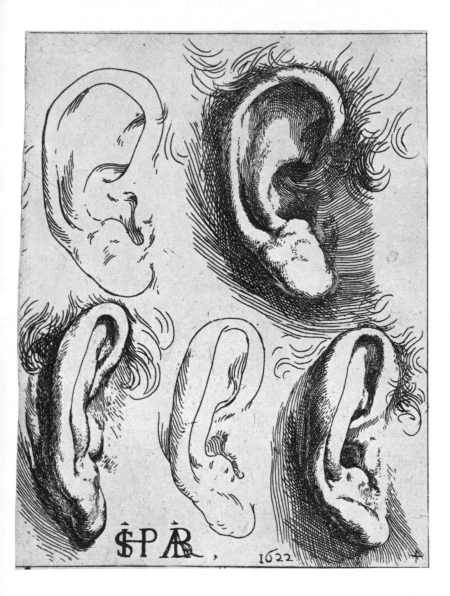

Figure 36
José de Ribera, Spanish, 1591-1652.
Page from a Copybook; *Studies of Ears*, etching $5\frac{7}{8} \times 4\frac{1}{2}$".
Courtesy of Mr. and Mrs. Leonard Baskin.

and remake till the portrayal ceases to be a secondhand formula and reflects the unique and unrepeatable experience the artist wishes to seize and hold." * Yet there is inherent difficulty and danger in equipping oneself with a schema or formula. Formula can guide. It can also over-channel, inhibit, actually block perceptual exploration and original vision.

Gombrich states concisely the opposition view: "Artists turned against the academies and the traditional methods of teaching because they felt it was the artist's task to wrestle with the unique visual experience which can never have been prefigured and can never recur." ** Of course, the alternative need not be expressed only in impressionist terms. Rembrandt had little regard for the "rules of art" and the formulas of the academy, then recently born. His instruction called upon his pupils to embrace nature, by which he meant not a collective idea but fluid life. His pupils drew extensively from the nude. They copied as well, their drawings being corrected by the master; but Rembrandt did not give them formulae. He weighted his teaching with the vitality of natural experience.

To assert nature to be the only necessary source of learning is, as Gombrich suggests, naïve. Yet, in turn, it is perhaps naïve to suspect that any sensible artist-instructor, who endorses nature fully as a mirror of learning, actually denies or ignores the beginner's need for an elementary vocabulary to cope with reality. But by throwing a student directly up against reality, an instructor does deny, as most artists in the twentieth century have, the verity of any "rules" in art, classical or otherwise; and he questions the meaning of representation. Further, he places both value and confidence on the individual and his unique vision. Aware of the young artist's need for some abstract basis on which to build, the instructor feels nonetheless that the student, with gentle direction, is capable of slowly extricating himself from the confusion of the particulars in experience, and can evolve through maturation his own personal "schema." The rewards warrant the difficulties of trial and error: surely this is as ideal a pedagogy as that of the academies. In truth the education of most artists ends up a mixture and compromise, a potpourri of many ideas and experiences from which we hope for the best, trusting in the strength of individual mind.

<div align="center">❖ ❖ ❖</div>

* E. H. Gombrich, *Art and Illusion*. London, 1960, p. 173.
** Gombrich, p. 174.

The revolutions in art of the last century are well known. Characterizing these revolutions perhaps more than any single quality would be the tendency toward visual abstraction; that is, a sharp turn away from representationalism and the surface appearances of nature, and instead an increased focus upon the formal elements responsible for the autonomous life of the work of art. The pedagogical offspring of formalism and abstract art follow the same form. Design (basic design workshops) is its most promising prodigy. If we continue the metaphor, then drawing in this context would be described as the malcontent sibling unwillingly overshadowed by the favorite child. Actually the two are nearly indistinguishable when placed in an abstract setting. Contemporary formalistic teaching of drawing concentrates upon the adventures of pure line, unattached, responsible only to itself and the page. Syntax—movement and measurement, line and form, line and space—all the abstract conditions of line, in relation to graphic materials, is the subject; exercise and experimentation, the method. The position of nature (again, in the most inclusive sense) in this situation will vary from none at all, to an analogical source for validation of theories and for inspiration. A parallel between the organic principles of art and those of nature exists and is recognized; but the actual use of natural phenomena is more indirect than may be found in any attitude toward drawing after the medieval illuminator. In fact, were it not for the extreme value contemporary art places upon creative mind and individuality of expression, a parallel to the medievalist would be quite marked. Then too, mastery of calligraphic line, abstract design, geometric structure were foremost. There are other differences that make the comparison as deceptive as it is illuminating. The contemporary artist, no matter the viewpoint he maintains, has behind him a 500-year tradition, which he may challenge—yet it bears influence on his art.

Paul Klee, probably the most outstanding of draftsmen who represent formalistic drawing, was fully cognizant of every formal development in the history of art and made inventive use of this knowledge. The drawing *Three Fruits* (Figure 37) by Klee animates his theories of lineation. We are first met by the playful imagination that delightfully infects his abstract intelligence; but as our eye is held longer, we begin to see his involvement with the orientation of forms in space, the figuration of movement, temporal reading, unification of differences, gravity, and growth of the organism which is the drawing. Klee's writings* re-

* Probably the best source is *Paul Klee: the Thinking Eye*, edited by Jurg Spiller. New York, 1961.

Figure 37
Paul Klee, German, 1879-1940.
Three Fruits (1927), pen and India ink, $10\frac{1}{8} \times 7\frac{1}{2}''$.
Collection, The Museum of Modern Art, New York.
A. Conger Goodyear Fund.

veal an articulate understanding of pure formal design and pictorial theory which has hardly been equalled. It is difficult to imagine this understanding existing in any previous century.

Simply put, the significance of an abstract formalistic outlook for the student is that his attention focuses on the events taking place upon the drawing surface. He learns the meaning of a line, a mark, a tone; he sees their dynamic interaction with the space of the page, their optical and psychological effects; he comes to understand the language of drawing in the abstract.

<div align="center">♦ ♦ ♦</div>

If we were to determine a pedagogical foundation on which to establish a program for the beginning student it would be that intoned throughout the text: a median between the experience of nature and formalism, with a strong cant toward the first.

The object of the student is to develop his ability to see—his visual intelligence—to grasp the sense of gesture and its relation to perception, to gain an understanding of both his pictorial and his material means— an overwhelming task. The instructor must provide a sequence of experiences that are designed to awaken the student's vision. Which specific problems are used and the extent and manner of the instructor's direction can only be determined in the given situation. A syllabus must be more than elastic; it should read like the computations of a tracking station, testing, sensing the circumstances and needs of the moment, every factor taken into account. An instructor may come directly to the issue or teach by devious means; he can instruct through lecture, discussion, texts, examples, demonstration, criticism, correction, but ultimately by making the student perform in drawing again and again in the face of changing problems.

For the convenience of discussion let us subdivide the subject into the following areas:

<div align="center">

gesture
material means
graphic elements
visual response
purpose

</div>

All of these have been examined, but now need to be seen in the present context as unique problems of the student. Also they must always be seen in view of the total organism, not as individual areas.

Although it may appear all too obvious, before considering the physical act we should describe proper drawing conditions. One may draw at an easel, or with paper mounted on a wall, seated on a drawing horse, or, which is most common, at a drawing table. In all these circumstances the same basic relation holds: the vertical axis of the drawing sheet must be centered with the draftsman's line of vision, neither to left or right, nor angled as is the habit in writing; the angle of the drawing surface should be such that the line of vision meets the center of the sheet at 90 degrees, which at a drawing table generally requires inclining the board; and lastly, the entire body must be alert, balanced, and uncramped, the arm should be completely free to move unhampered from fingers to shoulder. The student should not huddle over the board as though myopic, nor lean on the other arm half-attentive. Disregarding these conditions will hinder the drawing.

The analogy between drawing and dance has already been made. Vitality, grace, balance, surity, and fullness of motion are qualities that apply to movement in both arts. Seldom does the student show awareness of these qualities at the outset; of course, it is not a conscious awareness, rather an innate feeling—but one which can be developed or brought forth. One of the strongest tendencies to overcome is that toward hesitant, "stitched" lines which are made from countless, small back-and-forth strokes that cannot seem to find their path. Such lines are feelingless. A student will call it sketching; more accurately it can be described as hedging. The line, if it seeks anything, does so in the most feeble, languid manner. Continuity and fullness of motion are so important that they must be pursued from the beginning without hesitation (with an assumed confidence, if necessary). Whether the intended line is to be long, short, straight, curved, compound, or what, the hand should form it with firmness and vitality. It does not mean a draftsman will hit the mark every time; the problem is more complex than to allow for that but rarely. For every right line, a dozen failures precede.

One of the first problems given a student should require that he draw full, sustained lines of such length as to exercise and free the whole arm. Tall grasses and weeds are suited to this purpose as they offer a variety of subtle and compound curves for models. The drawn lines that trace their movement should be continuous and of the same length if possible. A student is most comfortable with a small sheet, the size he has become accustomed to in writing; but larger paper and drawing to utilize its dimensions will force him beyond habits of minuscule gestures that barely exercise the fingertips. Size in itself means nothing. However,

working in different scales should develop both visual control and adaptability of gesture.

Among those many devices of pedagogy which can enlighten and make the point (if used sparingly and appropriately) is the experience of drawing an imagined subject or a free pattern with the eyes closed. Sense awareness then concentrates entirely on the feeling of the movement, the pressure of pencil on paper, the hand holding the pencil, and speed of the movement. Feeling is heightened and gesture frees itself from the cautious eye. As with most educational devices, the problem often lies in transferring this experience to ordinary drawing situations. Pace and pressure are two factors a student must also develop as a means of increasing his vocabulary. The draftsman's graphic arsenal will include both the ability to perform slowly and deliberately or in acceleration; it will as well include a firm control with light or heavy pressure. This can be presented to the student as pure exercise or arise from the necessity of a subject, as again the weeds and grasses. A line implied by the movement (direction) of a form in space, such as the long curve and sudden bend of field grass, will suggest its own pace in the way our eye moves quickly or slowly along its course. Also, as its shape diminishes toward the end-point balanced in space, we will sense the lightness of line necessary to express this fact.

The real significance of gesture comes as a physical response to perceived or imagined images, not as an abstract ballet on paper. Drawing is a performance. Like any performance it requires skills in execution which are developed through practice and by understanding gesture as a corollary of vision. A draftsman can acquire extraordinary skill in making sure and elegent lines; these lines, however, will possess only the substance his artistic vision invests in them. "No excellence of execution can atone for meanness of conception." (Fuseli.) Modigliani, for one (See Figure 6, page 16), drew the line that matched the two.

Such is the physiognomy of a student's drawing that it readily reveals the temperament and bias of its author. By temperament we mean his timidity or temerity, dullness or sagacity, frivolity or earnestness, and so forth; and bias means here both predilection and prejudice in regard to his conception of drawing. An instructor learns to read these qualities of his student's mind. The bias may be of many kinds, and is possibly insurmountable; but one frequent tendency is a fascination with technique, and a misconception of its real meaning. Technique, the novice assumes, resides in the materials (for example, the technique of pen drawing or charcoal drawing); and further that this technique carries

with it by nature the method of representation. True, materials do affect and effect our vision, not, however, in any standardized way. To give the term more significant definition, technique should be understood as the outgrowth of an artist's personal union of material means —pictorial means—vision.

A fascination with "technique" must be shifted slightly so that it rests on the materials as such. Each time he draws with a new medium the student should test and explore it freely and discover, if possible, an empathy with it. He will only be able to do this once stereotype conceptions have been put aside and he has posed the questions: "What is this material like, what can I make it do?" Empathy for materials cannot be over-valued. It also cannot be taught. Other than discovering for oneself, the only alternate possibility is by recognizing this sense through the work of another artist.

The question of what and how great a range of materials should be used and explored is not so important as the student's discovering in what way the media he works with may alter the gestures of his hand or his vision. Here we begin to understand limitations of material means. If, for instance, we were to draw the same subject first with hard, sharpened graphite and then with a large stick of black chalk, the contrast in results should make the nature, and limitations, of each more apparent. Or too, the subtle differences between tools of the same family (reed and quill pen) might be discovered in the same manner. In either case the medium should be used in relation to a particular problem, responding to both the perceived form and the materials naturally; then the drawings could be compared to discover that perhaps the quill led to undulating, continuous gestures that tended to encircle the form like wound yarn, and the reed pen inclined toward abbreviated, more angular strokes which sought structure through economical notation. Admittedly, when we speak of approaching a problem in the most organic, natural way, it is quite difficult to separate preconceptions of a medium (quill pen) and the qualities found in its use. Having once seen a Guercino quill drawing, can we really put it away from the mind? What we discover finally to be the nature of a medium will be an assimilation of every way we have experienced the medium.

The same bias toward technique mentioned above affects the student's conception of the graphic elements. In some strange fashion graphic elements seem to become confused with material means and entangled in notions of mimesis. The true relation between drawing and experienced

reality must be understood and must displace patent concepts of drawing as imitation. A line does not imitate. It has an independent pictorial existence which can in some way parallel real things. A draftsman, then, translates, transposes, transmutates reality into lines and tones. The student need gain a knowledge of the graphic language and a fluency in its use; he must explore the alchemy of line, tone, and so on—but again, by facing the problem as a whole. Encountering real forms and given the task of articulating this experience on paper, the student will test the nature of the pictorial elements. A real form, like an idea, can be phrased one way, again in another, and another, until the meaning (structure) of the form seems to have been grasped and expressed by the marks.

The student must come to question for himself the possibilities of graphic elements. Because there is not a conventional language, except in architectural or engineering drawing, his mentor cannot provide him a vocabulary other than as a general point for departure. The case that would justify the teaching of an accepted language would be if all artists shared essentially the same vision and expression and the only problem for the student were to develop a skill in performance. But then the sense of art as we understand it now would be lost. In the medieval workshop this was possible. Under the influence of academic classicism it was also largely possible. Today it no longer applies. What can an instructor give his student? There are several ways to aid a student in understanding the pictorial means: by pointing out incoherency in his work or the ordinariness of a solution, indicating possible correctives, and underlining his successes; by exposing him to master examples that show not only excellence and invention, but variety; and through simple experiences that offer insight into the essential nature of the elements with which he works. In the last instance we mean the kind of exercises that actually force the novice draftsman to test the possibilities of line. Given the problem of describing a sphere without the use of tone-value, he would have to explore the means of line extensively in order to effect volume and not produce merely a circle. The problem can be solved a number of ways; but even miscalculated results with this assignment or others similar can be instructive in revealing what line will and will not do.

In addition, there are experiences outside drawing *per se* that demonstrate the optical dynamics of line—moiré patterns or the work of the perceptual abstractionists ("op" artists). Regardless of how inclined one may be toward this art, it can bring recognition of facts especially sig-

nificant to the student. Moiré patterns, named after the silk fabric, "are produced whenever two periodic [linear] structures are overlapped." * The resulting optical phenomena, as the appearance of undulations arising from the superimposition of two sets of straight parallel lines or two sets of concentric circles, are evidence for the potential of dynamic interaction latent in line. Paul Klee understood the lesson thoroughly and applied it creatively and with potent wit. The lesson of such illusionistic phenomena lies simply in the awareness that line does have a forceful existence of its own, that a draftsman cannot ignore either the abstract reality of the graphic elements or their vital interrelationships on the drawing surface.

We have made considerable point of the copy as a traditional method of teaching. Historically the function has been to acquire a proper use of means, sense of design, and knowledge of right proportion. What is its function and value for the contemporary student? The word *copy* might be replaced with *pastiche* (which unfortunately also has negative connotations); this term at least implies interpretation rather than mechanical reproduction. What the experience should represent is an investigation, an analysis, a questioning of a master's work. By re-enacting the drawing, we share in the master's thought and vision more intimately than by simply looking at the work. The eye is lazy; drawing urges it to probe more thoroughly, and it embeds experience into memory. Our own marks, even fumbling, should unfold the mechanisms of visual intelligence behind the drawing—the peculiar vision and personal definition of means from which the image grew. If what is studied is a painting, or sculpture, or a drawing of different materials, all the better. In transposing media we must necessarily make further interpretations of the sense of the work. To distill meaning from the pastiche study, the student must meet the experience with some grasp of the language, but more, with a knowledge of his own artistic problems. It therefore is not a method of didactic value to the beginning student as he has as yet nothing to which he can relate the experience. An advanced student or mature artist will be drawn to a master voluntarily because he feels admiration, because he senses a relatedness to his present needs, because he intuits the pertinence of the master's "solutions." The problem of eclecticism is real, but how many students ever actually avoid influence? Our eye absorbs the surface of ideas from other artists so quickly,

* This definition is taken from an article in *Scientific American* which provides an excellent source for further information on the subject of moiré. Gerald Oster and Yasunori Nishijima, "Moiré Patterns," *Scientific American,* Vol. 208/No. 5 (1963).

so efficiently, that we are barely conscious of this activity. If it must be, then we should make this activity as meaningful as possible by abstracting more than the surface. We must dig deep into the organism.

Visual response is perception, seeing; and in this context it cannot be less than the substance of the problem. *Learning to see;* everything this phrase represents—principally, a coalescence of intelligence and the sentient eye—becomes the real subject of the student. A coordination of understanding and feeling for materials, for pictorial means, the sense of gesture, and the visual mechanism itself is the instrument of visual response brought to the subject: sensed experience. The draftsman confronts visual experience and responds to it through the drawing. For the beginning student the problems inherent in this equation are compounded by inexperience and untrained perception. Only the extremely exceptional student comes to this discipline unburdened with patent vision. The instructor must unwind a whole circuit of conditioned responses and conventional orientation which seem to deny perception, at least as an active force. And he must break through any bias that inhibits visual exploration. His objective: to lead the student to a receptive encounter with experience, to bring him directly to an awareness of the sensations that impinge upon vision, but which often do not reach consciousness. Frequently the problem is described as the distinction between seeing and knowing. For example, given a common object such as a clay flowerpot, the student will draw the opening with an exaggerated ellipse, too close to a circle. Moreover, he will straighten the curve of the base. A kind of reverse perspective results. The cause? We *know* the pot has a circular opening, we know also that the base plane is flat in order for the pot to set right on a level surface. What we *know* about the object conflicts with what we *see*. If the object were placed on a table just below eye level, the circular top would appear as an extremely shallow ellipse; the flat, circular base would be seen as a fuller but smaller ellipse than the top, which is closer to eye level. What is seen by the beginning draftsman will lose out to what he knows; first, because of the difficulty in judging the relationships accurately, but more important, because what is seen does not seem to tell the story of the characteristic shape of the object. Actually it might be more to the point to say that what is already known about flowerpots substitutes for a real examination of the object as witnessed. But in fact most accounts of seeing and knowing are over-simplifications or distortions of the true complexities of perception. The knowledge we have formed from past experience is woven intricately into our percep-

tion. However, this much can be said: in the case of the flowerpot there is: (a) the object we observe that stands in specific relation to us and to its surroundings; and (b) the knowledge we possess about flowerpots, similar forms, objects in space, and such related information. As Gombrich has shown, we need something of the latter and also some elementary graphic schema in order to perceive the former and draw it. This does not alter the fact that more often than not such knowledge either substitutes for or hinders direct vision-contact with objective experience. Both instructor and student must assure as much as possible that what is brought to an experience sharpens vision.

Two common symptoms of conventional seeing are a concentration on objects rather than their spatial relationships; and with specific regard to the object, a focus upon outline or characteristic shape. To draw only this is to give our eyes an easy task. No draftsman can hope to grasp all aspects of what lies before him; but surely he should seek more than the outline of objects. Every drawing in this book shows concern in some way with form and space, and some with additional qualities—light, texture, movement, gravity. Visual response should mean an absorption of as much as the eye will hold. Though a draftsman may have a proclivity toward plastic form or light, as we have seen it will not obviate an awareness of other qualities. And here it may be emphasized that form (the three-dimensionality of objects) and space (spatial interrelationships) are the nuclei of a visual education. If a student can come to grips with the dimensional reality of objects and space defined by these forms, he will possess a foundation on which to develop in whatever way he chooses.

Obviously the drawing is an intricate part of visual response. The eye sees, the hand draws across paper, and the emerging pattern of marks leads the eye again further into its subject. This cycle of reciprocal action is the process of visual response, a process which the student must perform again and again until it would seem that draftsman = subject = drawing were one fused substance. That fusion could hardly be more real than in Rembrandt's *Woman Carrying a Child Down Stairs* (Figure 38). Gesture and vision are one thing—an event caught and held by the efficacy of intelligent draftsmanship. Rembrandt, acknowledged as a master storyteller, narrates in this drawing the story of his response to a moving figure holding a child. The transient fact must have passed quickly, although the movement may have repeated itself as the young woman continued down the steps. Still it would move by rapidly, leaving the artist with the image his inner eye was

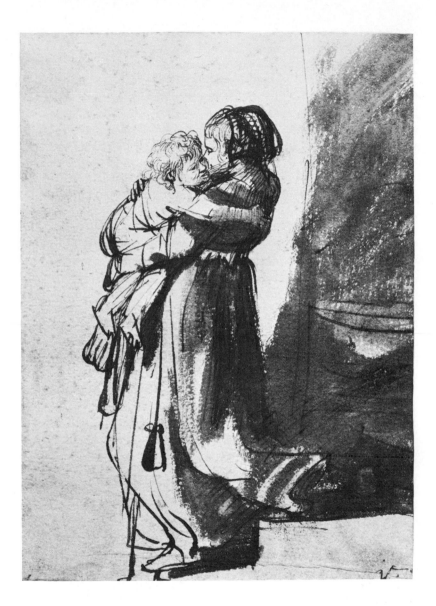

Figure 38
Rembrandt van Rijn, Dutch, 1606-1669.
Woman Carrying a Child Down Stairs (c.1636),
pen and brown ink, and brown wash, $7\frac{5}{16} \times 5\frac{1}{4}''$.
The Pierpont Morgan Library.

able to retain. And this he articulated clearly in the drawing; a much different problem than observing an unmoving object at one's leisure. The most fleeting, changing movement occurs in the lower half of the body, and here he has least developed the form. Motion is conveyed by the bending leg and trailing folds of the skirt which have been translated into the quick, full movements of the quill. The forward and downward thrust of the figure becomes compounded by the turn of the young woman's torso and the child pulling himself up to clasp her neck and shoulder. Perhaps the most eloquent movement is that encompassing the two figures as their arms wrap around each other, because through it we sense more completely the full form of the figures and the space in which they move. Every stroke of the pen in this area expresses this movement which acts to balance the rhythm of the descending woman. We may speculate that as the drawing began with the gesture of the bending leg and counter-arch of her back, Rembrandt saw the need to define clearly a secondary rhythm (encircling arms). He responded to the actual complexity of the event rather than settling for the most obvious fact. We might also suspect that the shadow was seen in the need to hold and stabilize the motion. It articulates the interlocking light and dark and divides the sheet in such a manner that we cannot help but be aware of the entire space—that from which the woman emerges and that into which she moves.

There is much more to be admired in the drawing: the descriptive use of fine and heavy strokes, the integration of brush wash and pen, and the beautiful definition of the form of the woman's head through the lines of her cap. But the pertinent fact lies in the depth of Rembrandt's response to the event he witnessed, sustained by the fresh memory of its occurrence. We would be mistaken to think of the drawing simply as a "recording" of this passing image. Through drawing he examined, clarified, and expressed what he had seen.

A beginning draftsman could not hope to cope with such a problem until he had acquired some understanding of drawing from more elementary experiences. The problems an instructor presents his students are his apparent means, devices to pique a lazy optic nerve. They should be designed as a sequence which leads the novice through a pattern of visual experiences giving him a fundamental, balanced, and varied background.

Finally we come to the question of a student's purpose. It would seem obvious that he intends to learn the language of drawing. True. But beyond this it must be emphasized that the purpose of graphic study

is to form *understanding;* understanding of the means, of perception, of the student's own personality, and—perhaps most important—an understanding of his experience and environment. Although we have stated and implied over and over that drawing is an instrument of inquiring vision, a means of understanding, it must be underlined in view of the considerable weight contemporary art education has placed on self-expression. Expression surely stands as the final object of art; however, it is expression of an individual's understanding of his art and his experience, not a catharsis of his emotions or sheer display of idiosyncratic personality. The student must set understanding as his goal, not self-expression; the latter will arise naturally from the former. In this light we can see that the value of the study of drawing goes beyond training professional artists. There is not one of us who could not profit from the education of our vision.

<div align="center">◇ ◇ ◇</div>

What is the pedagogical mirror? The metaphor can be applied in three ways. Most obviously, the student mirrors the teachings of his instructor, though often through opposition. But this is the least enlightening interpretation. A second would be nature, or experience, which reflects back to our eye the structure of things; a mirror from which we come to comprehend the relation between perception and the language of drawing. The third and most revealing interpretation finds the drawing itself to be a mirror of learning. Silvered-glass is the reflecting surface which enables us to see and examine our own image; a drawing acts as a reflection of the visual mind. On its surface we can probe, test, and develop the workings of our peculiar vision.

SEVEN

A New Disposition

The quality which most characterizes modern drawing is diversity. Divers media, themes, purposes, and artistic philosophies have created a topography of contrasts. If we examine this topography, the contrasts will be found both rich and shallow; but also, we will find that because it all exists in the single temperate zone of twentieth-century society, there are certain specific currents of values and concepts which distinguish the present scene from past history. Briefly, what are the currents that mark this terrain as distinct and what are the contours of its diversity?

Drawing in the twentieth century has followed the same convoluted path as the visual arts in general. But the journals of painting, sculpture, and even printmaking have been carefully kept and annotated, whereas drawing has more or less been appendixed to these. A survey of the first three decades reveals the same pattern of revolutionary "isms" and familiar names that forms the fundamental design of modern painting and sculpture: fauvism, cubism, expressionism, dadaism, futurism, abstractionism, surrealism; Matisse, Picasso, Braque, Gris, Munch, Rouault, Kandinsky, Klee, Kokoschka, Kirchner, Kollwitz, Nolde, Arp, Mondrian, Brancusi, Duchamp, Boccioni, de Chirico, Modigliani, Masson, Ernst, Chagall—and how many more names that have been etched

into recent history by the mordant of their achievements. Drawing has been integral with the ideas and expressions these artists have pursued, with the legends they have created. This has always been true. But the nature of the integration has been altered somewhat from the traditional form. It amounts to the intermeshing of the concepts—to draw = to paint = to sculpt—which has been so characteristic of this century as to challenge any firm distinction between categories of art-making. The act of executing (creating), the spontaneity, energy, economy, and the tendency to compress, which are aspects of drawing, have become extremely important to the whole of the visual arts. We may consider them, in fact, basic contemporary artistic values. The traditional separation between the sketch studies and the final, finished work in which the sketch held a clearly secondary position, has been nearly reversed. We are inclined to give sketches the better fare of our criticism. We value their immediacy and free expression, having made of the energetic sketch and its related forms something of considerable virtue. In a drawing one can retrace the events of its making; and now to find these same traces, the signs and birth scars of creation, in painting or sculpture is a positive value. And quite rightly—why should they be concealed? Yet the sketch has become a fetish; "spontaneity," "economy of line," overt "expressional power" have become factitious values, through overemphasis—false gods. The miracle of a few lines by Rembrandt or Picasso cannot be transposed to any few lines hastily executed.

Pictorial elements have become increasingly autonomous. Line operates as line—proclaiming itself—in contemporary drawing, printmaking, painting, and sculpture. We may see this in the Franz Kline, *Turin* (Figure 39), an oil pointing in which powerfully concrete line is absolute. The usual multi-hued habit of painting has been completely removed. Those qualities which we have found define the first phase of drawing are here the key phrase of expression. Is this a drawing in oil paint? Or, is it a painting materializing the ideas of the other discipline? —Or does the question really matter? Abstract expressionism or action painting, which dominated the decade and a half following World War II, placed considerable emphasis on the act of creating, on the gesture of making; and one finds that this gesture, as in Kline, is a fusion of the act of drawing and the substance of paint, most often performed on a monumental scale. The traditional pattern of preparatory studies was largely eschewed in order to compress the excitement, the energy, the whole cycle of development into the events of a single painting. In other words, the essential role of drawing for these artists was in the

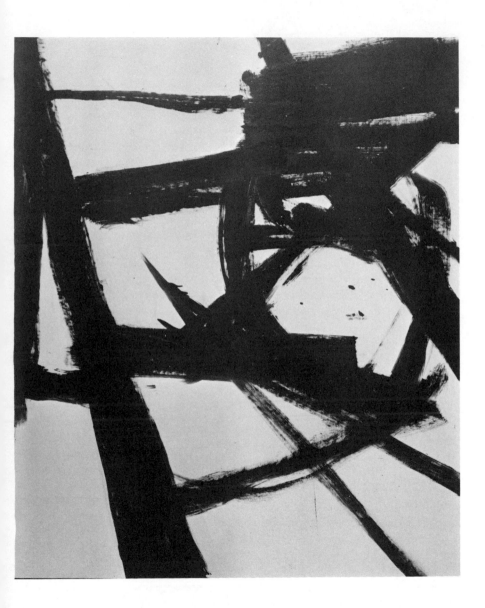

conceptual act and the physical performance as it occurred in the painted work itself. It is not that their *oeuvre* lacks drawings, but those there are represent a surfeit of painting activity rather than an essential nourishment.

The desire of some painters to tighten the relation between their drawings and their paintings, by no means unusual in the history of art, has produced in our century works which test the limits of the drawing category. Indeed, they deny that an immutable definition of drawing can exist. Since the mid-sixteenth century draftsmen have borrowed more and more the elements of tone-value and color and expanded, as well, the range of their material means. Edward Corbett's *Number 11* (Figure 40) exemplifies what is often referred to as "painter's drawing." It presents an image as formless as a Whistler fog —totally, or nearly so, a composition of tone-value. It is an ambiance, a mood, a space-landscape in which clouds of gray fog break to partly reveal an indeterminate structure beneath; an image as metaphorical and contemporary as Eliot's:

> *When the evening is spread out against the sky*
> *Like a patient etherised upon a table.*

The role Corbett's drawing plays appears to be interchangeable with his paintings (some of which have an even closer affinity to Eliot's lines above), except that oil paint always conveys a more concrete and permanent impression.

In large, the media contemporary draftsmen have chosen have been those employed for the last half-millennium, if now in modern synthetic versions. But inventive temperaments and avant-garde philosophies have influenced individual artists to explore new materials and introduce new combinations of media. Watercolor, gouache, casein, tempera, and oil paint all have been used more frequently by draftsmen than in the past. Wax, varnish, alcohol, plastics, colored transparent inks, printer's inks, and photographic film; stencil, transfer, rubbing, imprint, monotype, and collage—all are media and methods which contemporary

Figure 39
Franz Kline, American, 1910-62.
Turin (1960), oil on canvas, 80 × 95".
Nelson Gallery—Atkins Museum, Kansas City, Missouri.
Gift of Mrs. Alfred B. Clark.

artists have brought to drawing in search of new forms and an individual expression. In the best work this expansion of materials arises from personal necessity and is enforced by an inventive, exploratory sensibility. Otherwise they are only a diversion or an ersatz form designed to conceal vacant talent.

The cult of the New, of the Original, has led too often to bizarre fabrications and a curious imbalance of artistic aims. Eccentric materials, techniques, and forms do not necessarily equal creative vision. Jean Dubuffet has shown, however, that the equation can be exacted. In the case of his *Black Countryside* (Figure 41), it is not the materials, but the method, which is the sign of a new disposition. Collage, or more accurately *assemblage,* is a distinctly twentieth-century idiom, intimately tied to the artistic revolutions of the last fifty years. Essentially it must be considered a medium of its own, standing somewhere between drawing, painting, and sculpture, having influence on them all. Collage has been an auxiliary means for many contemporary draftsmen. When Picasso glued newspapers onto his drawing sheet, when Jean Arp tore a drawing and rearranged it according to the "laws of chance," they had each broadened the scope of drawing by introducing methods which would either compound the visual reality of the drawing or would make *chance* an operable factor in the development of an idea. A number of artists have used these methods as a kind of *ad hoc* technique (that is, temporarily, not as a final mode of expression) to deliberately upset their habitual working pattern and alter the configuration of an image in unexpected ways. This indicates how considerably important the element of *discovery* has been in twentieth-century art: not to give form to a pre-conceived idea (image), rather to *discover* the image in the work—that is the artist's goal. Dubuffet describes his drawing-collages thus:

"All my work with assemblages . . . [was] not so much undertaken with the idea of realization as in the spirit of preliminary research, with a view to future realizations. In short, they were for me what prelim-

Figure 40
Edward Corbett, American, 1919— .
Number 11 (1951), chalk, 36 × 24$\frac{1}{8}$".
Collection, The Museum of Modern Art, New York.
Katherine Cornell Fund.

*inary sketches of a painting are for other painters. This assemblage tech-nique, so rich in unexpected effects, and with the possibilities it offers of very quickly changing the effects obtained through modifying the dis-position of the haphazard pieces scattered on a table, and thus of mak-ing numerous experiments, seemed to me an incomparable and an efficacious means of invention." ***

These ink-assemblages are a materialization of an imaginative vision and expressive temperament signifying an artistic current of unortho-doxy and iconoclasm. If Dubuffet is correct in comparing these to "what preliminary sketches are for other painters," it is true in a most unusual sense. They have nothing of pre-determination, they are far apart from the reasoned, step-by-step development into a final work. The drawing we reproduce is a single realization in the stream of a creative idea— but once it is brought into being, it exists independently and is not contingent upon further development:

*"Besides, I really believe that the hasty effects and unfinished charac-ter of a painting [drawing] adds to the pleasure it gives me, and I sel-dom feel that the effects I have sketched need a more meticulous execu-tion." ****

Of course contemporary artists have continued to employ drawing in the traditional dialectic manner. Andrew Wyeth is such a draftsman. His quiet and careful studies (see Figure 42) document in the most precise fashion the external elements of Wyeth's own environment (and imply the intrinsic mood) with a finality that a Pieter Claesz would envy, but with a warmth and affinity few Dutch still-life masters ever approached. It is a way of seeing exactly antithetical to Dubuffet's. And yet their two drawings were created in the same decade. Does that mean one should judge Wyeth's art to be anachronistic? If the question need be asked at all, it may be answered thus: of the two, Wyeth clearly holds a firmer tie to the nineteenth century, to Thomas Eakins most especially; but his mood and his construction of that mood (not the stylistic idiom) belong to his contemporary milieu. The question, how-ever, veils the marvel that two contemporary, singular talents can pro-duce such completely disparate visions. We are the benefactors who can participate in both their arts. Are there other artistic periods that can

* Quoted in Peter Selz, *The Work of Jean Dubuffet.* New York, 1962, pp. 104-05.
** Selz, p. 106.

Figure 41
Jean Dubuffet, French, 1904 —.
Black Countryside (1955), collage of painted paper, $25\frac{1}{2} \times 23\frac{1}{8}''$.
Collection, The Museum of Modern Art, New York.
Gift of Mr. and Mrs. Donald H. Peters.

claim such contrasts in point of view? This multiformity of vision reaches even further extremes than these examples. The freedom and the esteem of individualism it signifies are more consequential than any single dimension of twentieth-century drawing. Can we not consider it actually the dynamic, viable spirit of modern art?

<center>❖ ❖ ❖</center>

Throughout the text we have found that drawing may fit into an artist's larger stream of production in many ways. Drawing as preparatory for a specific final work, as an instrument to measure experience, as a means to modify and solidify the vague, emotive forms of imagination, and as a medium of expression complete in itself; all of these apply to the graphic art of the present and surely will continue to hold in the future. The last, however—the complete expressional statement —has been more common in recent drawing than in any previous century. In the past, the autonomous drawing was a much more isolated affair. It probably remains the smaller percentage; but the acceptance and understanding of drawing as an expressional end, in fact, of the drawing discipline as a whole is far wider both among artists and the art public. The signs of this are the increased exhibitions, competitions, collections, and publications devoted entirely to drawings.

Drawings and draftsmen should not be zoned. Of course we have done our share of it, and in a way, we are continuing to do so by suggesting that the work reproduced in this chapter (excepting Wyeth and Kline) consists in the function of complete expression. Perhaps we should resist verbal garlands and let these drawings speak for themselves —for the authors, as the authors themselves intended. Examine them. Press the ideas we have evolved hard against them. And consider this: a drawing as an expressional statement differs from an oil painting or a work in other media due to the qualities we have found peculiar to drawing. Because of these qualities, because of a commitment or inclination to the graphic conception, because an individual senses an integrity between his vision, his expression, and the language of drawing, he employs these means to give his imagery substance.

Figure 42
Andrew Wyeth, American, 1917 – .
Slippers (1959), pencil, 21 × 13½".
Courtesy of Mrs. Andrew Wyeth.

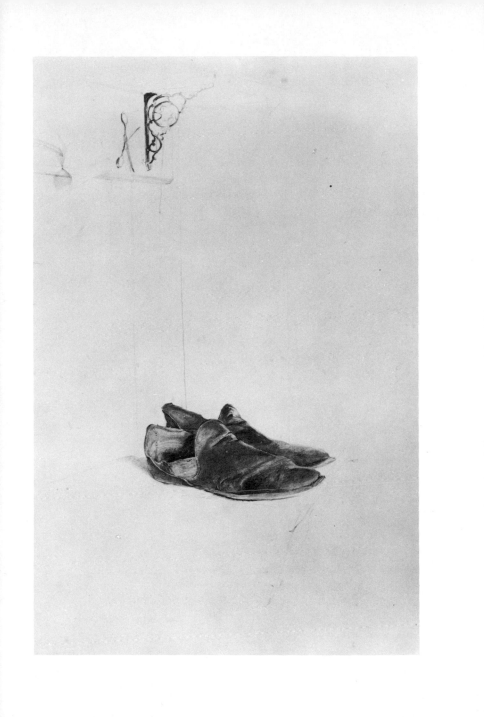

If a new disposition exists it is multi-faceted; it emerges from every aspect of drawing we have examined; but this disposition takes on the temper of the present and acclaims its fullest measure in the drawing which has been conceived as complete and concrete expressive form. Each of these drawings (in fact all we have reproduced) displaces a point in the history of drawing and by extension contains within itself a chronicle of all previous drawing; yet, each is an instrument and embodiment of personal vision. It is not how well a draftsman performs, but the special way he possesses the *idea* of drawing. Every drawing defines drawing anew.

The following drawings
are intended as an adjunct to Chapter Seven,
and are presented without commentary
as a sampling of recent work by a variety of artists
who use drawing as a means of expression complete in itself.

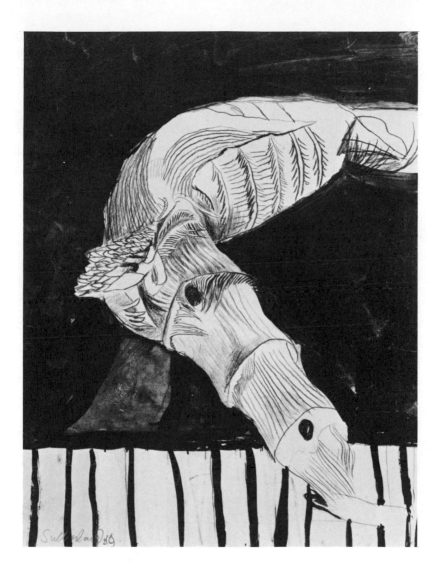

Figure 43
Graham Sutherland, English, 1903 — .
Articulated Form (1949), black chalk and wash, $14\frac{1}{8} \times 11\frac{1}{8}''$.
The National Gallery of Canada, Ottawa.

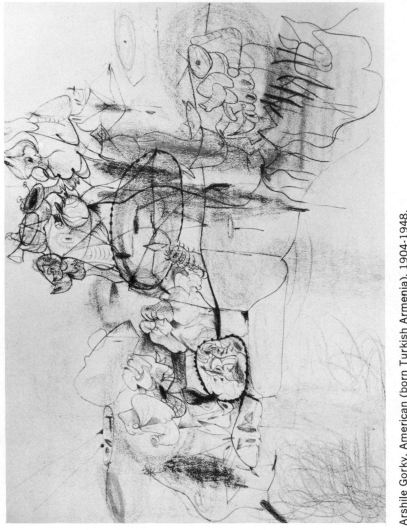

Figure 44 Arshile Gorky, American (born Turkish Armenia), 1904-1948.
Virginia Landscape (1943), pencil and wax crayon, 20 × 27".
Collection of Mr. and Mrs. Stephen D. Paine, Boston, Massachusetts, photo by Barney Burstein.

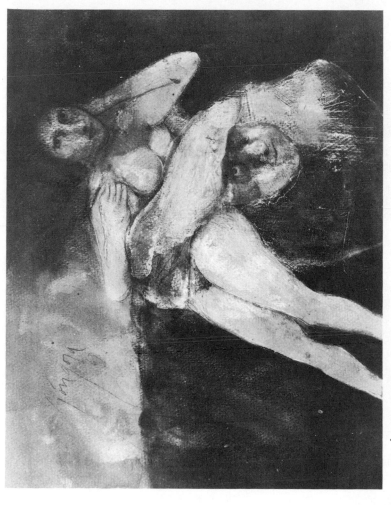

Figure 45 Leonel Góngora, Colombian, 1932 — . *Travelers* (1964), acrylic and colored inks, $9\frac{3}{4} \times 12\frac{3}{4}''$. Courtesy of the Cober Gallery, New York, photo by Eric Pollitzer.

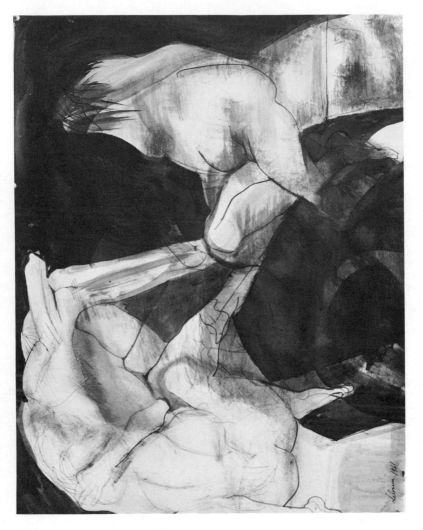

Figure 46 Rico Lebrun, American (born Italy), 1900-1964.
Tormented Shades (1961), ink and wash, 21 × 28½". Courtesy of Mrs. Rico Lebrun.

Figure 47
Rico Lebrun, American (born Italy), 1900-1964.
Adam and Eve (detail for mural of *The Genesis* at Pomona College,
Claremont, California), ink, wax and casein, 108 × 59″.
Courtesy of Mrs. Rico Lebrun.

Figure 48
Hyman Bloom, American, 1913 — .
Trees #2 (1962), charcoal, $69 \times 30\frac{1}{2}''$.
Collection of Mrs. Jerry Goldberg,
photo courtesy of Museum Color Slides Association.

Figure 49
Leonard Baskin, American, 1922 —.
Sheriff (1965), pen, brush and ink, 40 × 26½".
Borgenicht Gallery, Inc.

Figure 50 Edward Hill, American, 1935. *W.O.: Anthem for Doomed Youth* (1965), pen and brown ink and polymer-acrylic wash on beige paper, 18 × 24″. Courtesy of Mrs. J. L. B. Sullivan.

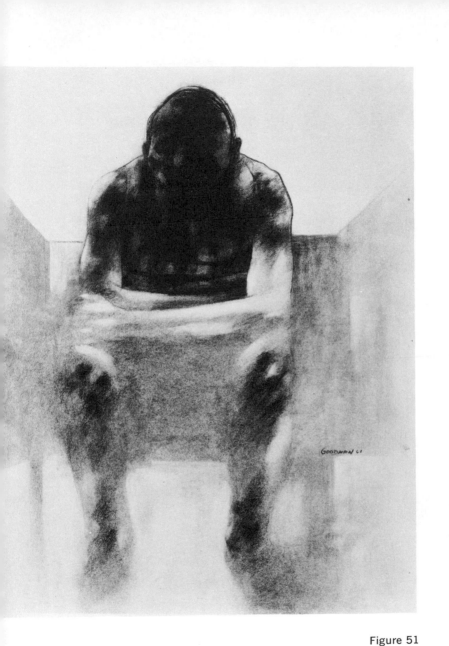

Figure 51
Sidney Goodman, American, 1934 —.
Man Waiting (n.d.), charcoal, approximately 34 × 26".
Collection, The Museum of Modern Art, New York.
Gift of Mr. and Mrs. Walter Bareiss.

Figure 52
Eustache Le Sueur, French, 1617-1655.
Study of the Head of a Saint,
black and white chalk on tan paper, $7\frac{1}{4} \times 6\frac{3}{8}''$.
Collection of the author.

Bibliography

I

General Texts

Blake, Vernon, *The Art & Craft of Drawing*. London: Oxford University Press, 1927.

De Tolnay, Charles, *History & Technique of Old Master Drawings*. New York: H. Bittner & Co., 1943.

II

Technical (Methods and Materials)

Cennini, Cennino, *The Craftsman's Handbook (Il Libro dell' Arte)*. Translated by Daniel V. Thompson, Jr. New Haven: Yale University Press, 1933.

Meder, Joseph, *Die Handzeichnung: Ihre Technik und Entwicklung*. 2nd ed. Vienna: A. Schroll & Co., 1923.

Nicolaïdes, Kimon, *The Natural Way to Draw*. Boston: Houghton Mifflin Company, 1941.

Watrous, James, *The Craft of Old-Master Drawings*. Madison: University of Wisconsin Press, 1957.

III

Anthologies and Collections

Ayrton, Michael, *British Drawings*. London: Collins, 1946.

Bean, Jacob, *100 European Drawings in the Metropolitan Museum of Art*. New York: Metropolitan Museum of Art, n.d.

Bean, Jacob and Felice Stampfle, *Drawings from New York Collections I, The Italian Renaissance*. New York: Metropolitan Museum of Art Pierpont Morgan Library, 1965.

Cantón, F. J. Sánchez, *Spanish Drawings*. New York: Shorewood Publishers, Inc., 1964.

　　This is one in a series, *Drawings of the Masters,* which together cover the whole of the history of drawing by nationality and period. Each volume contains an excellent essay by a well-known historian.

Eisler, Colin T., *Flemish and Dutch Drawings*. (Drawings of the Masters Series) New York: Shorewood Publishers, Inc., 1963.

————, *German Drawings*. (Drawings of the Masters Series) New York: Shorewood Publishers, Inc., 1963.

Grigson, Geoffrey, *English Drawing*. London: Thames and Hudson, 1955.

Haverkamp-Begemann, Egbert, Standish D. Lawder, and Charles W. Talbot, Jr., *Drawings from the Clark Art Institute*. New Haven: Yale University Press, 1964.

Hayes, Bartlett H., Jr., *American Drawings*. (Drawings of the Masters Series) New York: Shorewood Publishers, Inc., 1965.

Moskowitz, Ira (ed.), *Great Drawings of All Time*. 4 vols. New York: Shorewood Publishers, Inc., 1962.

Sachs, Paul J., *Modern Prints and Drawings*. New York: Alfred A. Knopf, Inc., 1954.

Schoolman, Regina and Charles E. Slatkin, *Six Centuries of French Master Drawings*. New York: Oxford University Press, 1950.

Wheeler, Monroe (ed.), *Modern Drawings*. New York: Museum of Modern Art, 1944. Contains an excellent essay by M. W. and John Rewald, "Modern Drawings."

IV

Selected Monographs

　　The listing below is necessarily limited to those artists whose drawings have been reproduced in this book.

　　Listed alphabetically according to artist.

Leonard Baskin

Leonard Baskin. Catalogue to an exhibition at Bowdoin College. Note on the drawings by Winslow Ames. Brunswick, Maine: 1962.

Hyman Bloom

"Eight Drawings by Hyman Bloom," with a note by Hyman Swetzoff. *The Massachusetts Review,* Vol. III, No. 3. Amherst, Mass.: Spring 1962.

Umberto Boccioni

Taylor, Joshua C., *The Graphic Work of Umberto Boccioni.* New York: The Museum of Modern Art, 1961.

Paul Cézanne

Chappuis, Adrien, *Les Dessins de Paul Cézanne, au cabinet des Estampes du Musée des Beaux-Arts de Bâle.* Olten et Lausanne: Editions Urs Graf. 1962.

Neumeyer, Alfred, *Cézanne Drawings.* New York: Thomas Yoseloff, 1958.

Lovis Corinth

Biermann, Georg, *Der Zeichner Lovis Corinth.* Dresden: Verlag Ernst Arnold, 1924.

Netzer, Remigius, *Lovis Corinth Graphik.* Munich: R. Piper & Co., 1958.

Jean Dubuffet

Cordier, Daniel, *The Drawings of Jean Dubuffet.* Translated by Cecily Mackworth. New York: George Braziller, Inc., 1960.

Selz, Peter, *The Work of Jean Dubuffet.* New York: The Museum of Modern Art, 1962.

Jaques de Gheyn

Regteren Altena, J. Q. van, *The Drawings of Jaques de Gheyn.* Amsterdam: Swets, 1936.

Arshile Gorky

Schwabacher, Ethel K., *Arshile Gorky.* New York: The Macmillan Company for the Whitney Museum, 1957.

Goya

López-Rey, José, *A Cycle of Goya's Drawings.* New York: The Macmillan Company, 1956.

Guercino

Marangoni, Matteo, *Guercino.* Milan: Aldo Martello Editore, n.d.

J. A. D. Ingres

Wildenstein, George, *Ingres.* New York: Phaidon, 1954.

Paul Klee

Grohmann, Will, *Paul Klee Drawings*. New York: Harry N. Abrams, 1960.

Oskar Kokoschka

Kokoschka Drawings, introduction by Paul Westheim. London: Thames and Hudson, 1962.

Kaethe Kollwitz

Bittner, Herbert, *Kaethe Kollwitz Drawings*. New York: Thomas Yoseloff, 1959.

Rico Lebrun

Drawings. Berkeley and Los Angeles: University of California Press, 1961.

Drawings for Dante's Inferno by Rico Lebrun, introduction by John Ciardi and Leonard Baskin. New York and Los Angeles: Kanthos Press, 1963.

Leonardo da Vinci

Popham, A. E., *The Drawings of Leonardo da Vinci*. New York: Reynal & Hitchcock, 1945.

Michelangelo

Goldscheider, Ludwig, *Michelangelo Drawings*. 2nd revised ed. London: Phaidon Press, 1966.

Amedeo Modigliani

Modigliani, Drawings from the Collection of Stefa and Leon Brillouin. Catalogue to an exhibition with an introduction by Agnes Mongan. Cambridge: Fogg Art Museum, Harvard University, 1959.

Piet Mondrian

Seuphor, Michel, *Piet Mondrian, Life & Work*. New York: Harry N. Abrams, Inc., n.d.

Pablo Picasso

Pablo Picasso Drawings, with an introduction by Maurice Jardot. New York: Harry N. Abrams, Inc., 1959.

Antonio Pisanello

Sindona, Enio, *Pisanello*. New York: Harry N. Abrams, Inc., 1961.

Jacopo Pontormo

Rearick, Janet Cox, *The Drawings of Pontormo*. 2 vols. Cambridge: Harvard University Press, 1964.

Odilon Redon

Berger, Kraus, *Odilon Redon*. New York: McGraw-Hill Book Company, 1965.

Rembrandt

Benesch, Otto, *The Drawings of Rembrandt*. 6 vols. London: Phaidon Press, 1954-57.

Georges Seurat

Herbert, Robert L., *Seurat's Drawings*. New York: Shorewood Publishers, Inc., 1962.

Charles Sheeler

Charles Sheeler, with an introduction by William Carlos Williams. New York: The Museum of Modern Art, 1939.

Graham Sutherland

Cooper, Douglas, *The Work of Graham Sutherland*. New York: David McKay Co., Inc., 1961.

G. B. Tiepolo

Hadeln, Detlev, freiherr von, *The Drawings of G. B. Tiepolo*. 2 vols. New York: Harcourt, Brace & World, Inc., n.d.

Antoine Watteau

Parker, K. T. and J. Mathey, *Antoine Watteau*, catalogue complet de son *Oeuvre Dessiné*. Paris: Société de reproduction de dessins anciens et modernes, 1957.

Andrew Wyeth

Andrew Wyeth, Dry Brush and Pencil Drawings. Catalogue of an exhibition organized by the Fogg Museum, Harvard University, with an introduction written by Agnes Mongan. Cambridge: 1963.

V

Essays and Articles

Ayrton, Michael, "The Act of Drawing," *Golden Sections*. London: Methuen & Co., Ltd., 1957.

Berger, John, "Drawing," *Permanent Red*. London: Methuen & Co., Ltd., 1960.

The Drawing Society, *Approaches to Drawings*. (Essays by Philip Hofer, Jacob Bean, and Gabor Peterdi) New York: The Drawing Society, 1963.

Huyghe, René, "Drawing and the Hand," *Art and the Spirit of Man*. Part 1, Chapter I. New York: Harry N. Abrams, Inc., 1962.

Lamb, Lynton, "Drawing," *Preparation for Painting*. Chapter V. London: Oxford University Press, 1954.

Master Drawings. Vol. 1, No. 1. New York: Master Drawings Assoc., Inc., Spring 1963.

Mongan, Agnes, "European Landscape Drawing 1400-1900: A Brief Survey," *Daedalus.* Vol. 92, No. 3. Cambridge: Summer 1963.

VI

Other Books Referred to in Text

Cassirer, Ernst, *An Essay on Man.* New York: Doubleday & Company, Inc., n.d.

Clark, Kenneth, *The Nude, A Study in Ideal Form.* Bollingen Series XXXV-2. New York: Pantheon Books, Inc., 1956.

Gombrich, E. H., *Art and Illusion.* Bollingen Series XXXV-5. New York: Pantheon Books, Inc., 1960.

Mason, Endo C., *The Mind of Henry Fuseli.* London: Routledge & Kegan Paul, Ltd., 1951.

Oppé, Adolf P., *Alexander and John Robert Cozens.* Cambridge: Harvard University Press, 1954.

Sze, Mai-Mai, *The Tao of Painting.* Bollingen Series XLIX, 2nd ed. New York: Pantheon Books, Inc., 1963.

Wind, Edgar, *Art and Anarchy.* London: Faber & Faber, Ltd., 1963.